Historic England

Portsmoutn

Philip MacDougall

AMBERLEY

About the Author

Philip MacDougall, a former teacher at Portsmouth College, has been writing about Portsmouth for several decades, with his initial interest focussing on the naval dockyard and its 500-year history. For Portsmouth Museums he has written *Settlers, Visitors and Asylum Seekers: Diversity in Portsmouth since the late 18th Century*, published in 2002, while his most recent book on Portsmouth, from Amberley Publishing in February 2017, is *Portsmouth Dockyard Through Time*.

First published 2017

Amberley Publishing
The Hill, Stroud, Gloucestershire, GL5 4EP
www.amberley-books.com

Contents

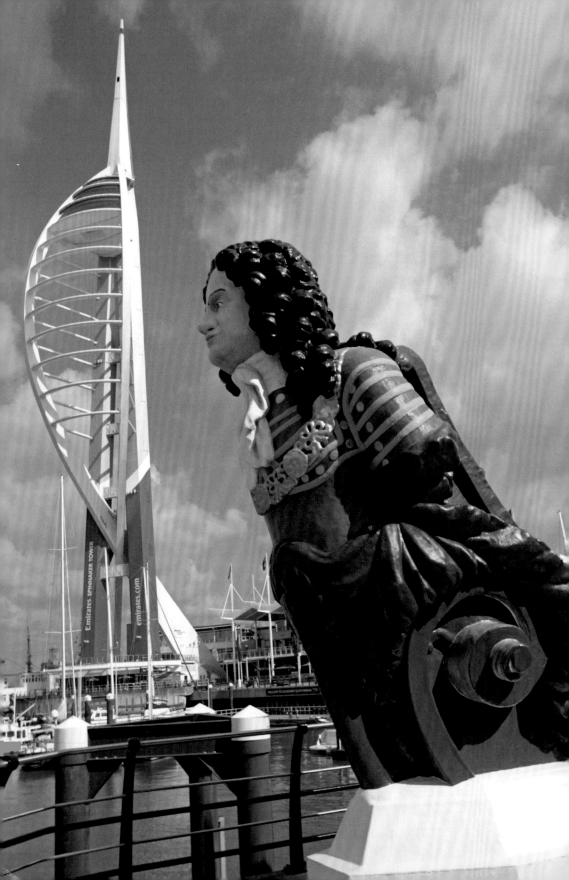

Introduction

Portsmouth will forever be associated with the Royal Navy, a link that began during the reign of Richard I (r. 1189–99). It was Richard who ordered the construction of the first dockyard, a galley arsenal situated on land that now lies immediately north-west of the present-day Gunwharf Quays. From a relatively small beginning, following a gap of nearly three centuries, emerged the much larger dockyard begun by Henry VII (r. 1485–1509) and which, through building, rebuilding and various additions and extensions, paved the way for the twenty-first-century naval base that will be home to the 'Queen Elizabeth' class aircraft carriers, each weighing 65,000 tonnes.

Of course, there is more to Portsmouth than the former dockyard and naval base. From a cluster of small isolated settlements in the early Middle Ages, what we now know as Portsmouth steadily expanded, with this growth first centred on Portsea Island's south-west quadrant. In time, the various separate communities that once existed on Portsea were absorbed into this development process. This has resulted in the wider area that is now known as Portsmouth also including Highbury, Cosham and Drayton – areas never encompassed by the island of Portsea, being instead part of the mainland of the north.

Southsea, on the south-east side of Portsea Island, developed as a seaside resort in the nineteenth century. It was greatly favoured by the middle class but is now, in parts, as compact with housing as anywhere else in Portsmouth. As to any early dreams that might have existed for Southsea to be made into a serious rival to Brighton or Blackpool, these were crushed in the post-war years when it was finally realised that not only would the investment require too large a proportion of the council rates, but that Southsea simply lacked the necessary open space to provide all the amenities required. A visitor attraction that now overshadows Southsea is the former industrial-military complex that was once centred on the dockyard, with the Historic Dockyard attracting annual visitor numbers in excess of 600,000. Here Nelson's flagship *Victory* is to be found, held in dry dock since April 1925 but now joined by *Mary Rose*, *Warrior* and the National Museum of the Royal Navy.

In this book the growth of Portsmouth from town to city status, the development of Southsea as a seaside resort, construction of an airport, early entertainment and shopping experiences, the tragic years of the Blitz and the lengthy post-war years of rebuilding and regeneration are all viewed through the eyes of contemporary photographers. Making this book especially unique is extensive use of aerial pictures, which permit a very different appreciation of city life. Using these photographs, and with a particular emphasis on the mid- to late-twentieth century, Portsmouth is seen at the time of its greatest transformation, a time when it possibly underwent more change – in a shorter period of time – than ever witnessed in any other city in the country.

Arriving in Portsmouth

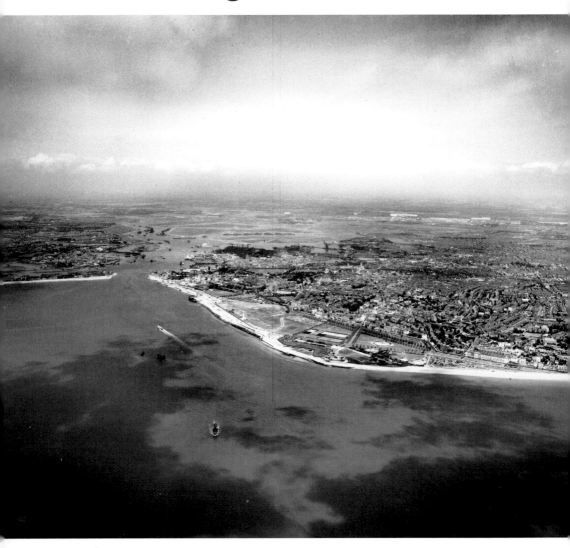

Southsea Castle and Common

An aerial view, taken in May 1947, of the entrance to Portsmouth Harbour, also showing Southsea Castle and Common. The harbour has long been a gateway in and out of Portsmouth, both for commercial ferry companies and the Royal Navy. It is apposite, therefore, that the harbour should be the starting point for this illustrated tour of Portsmouth's past. From the ferries entering and leaving the harbour, the medieval defences protecting the entrance are clearly visible and are also seen in this photograph. More recently, this area of seaway has witnessed the removal of 3 million cubic metres of seabed to make the approach channel deeper, allowing the nation's new aircraft carriers to make Portsmouth their home base.

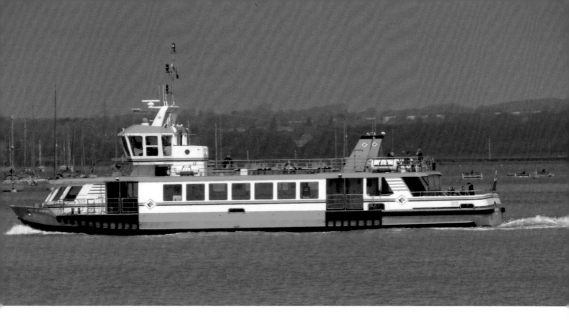

Spirit of Gosport
The ferry *Spirit of Gosport* crosses the harbour. Since the reign of the Tudor monarchs, ferries have operated between Gosport and Portsmouth, their work essential for both the dockyard and local commerce, allowing those who live in Gosport to use the city as a place of work, entertainment and shopping. The present-day ferry company is one of the longest-running ferry services in the UK and was first established in 1883.

A Paddle Steamer on the Solent off South Parade Pier, Southsea, from the South, 1949
A paddle steamer makes its way across the Solent from South Parade Pier carrying passengers to Ryde Pier head on the Isle of Wight. Seen here on 23 July 1949, the vessel is probably *Shanklin*, built by J. I. Thornycroft at Southampton in 1924 for Southern Railway to operate on their Portsmouth–Ryde service. Only during the summer was a service run from South Parade Pier, this to meet the demand of large numbers of holidaymakers.

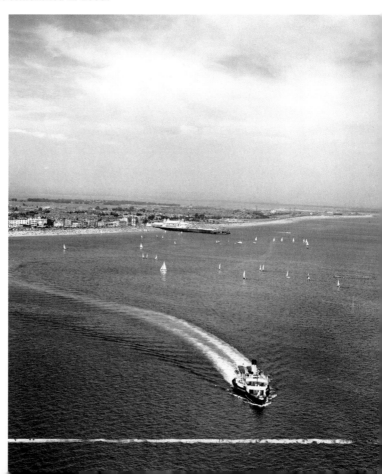

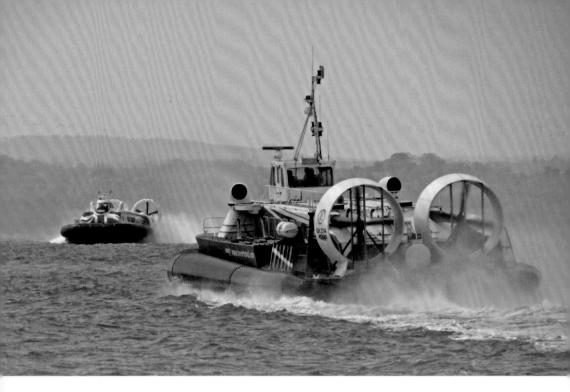

Hovercraft, Southsea, May 2017
The only remaining commercial hovercraft service in the world links Portsmouth to the Isle of Wight and takes just ten minutes to cross between Ryde and Southsea. Operated by Hovertravel, part of the national rail network, there are two craft in its fleet – *Island Express* and *Freedom 90* – with both craft having given over thirty years of service.

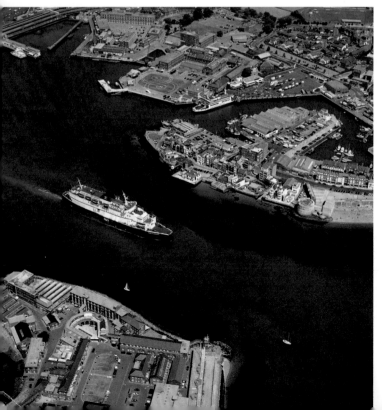

The *Pride of Cherbourg* Leaving Portsmouth Harbour, 1995
The *Pride of Cherbourg*, the second ship to carry that name, leaves Portsmouth Harbour on 20 July 1995 bound for Cherbourg. It was in September 2004 that P&O announced that they were no longer to run ferries on that route. Brittany Ferries eventually acquired the route, which is now operated by *Normandie Express*, a fast catamaran ferry.

Portsmouth Harbour Railway Station, Portsmouth, 1968
Aerial view of Portsmouth Harbour Railway Station as seen on 14 March 1968. First opened on 2 October 1876, the station now regularly sees over 2 million passengers passing through each year. Among the vessels to be seen in the harbour are a couple of moored landing craft for tanks and a pair of naval minesweepers, while a British Rail Isle of Wight ferry can be seen close to the pier head.

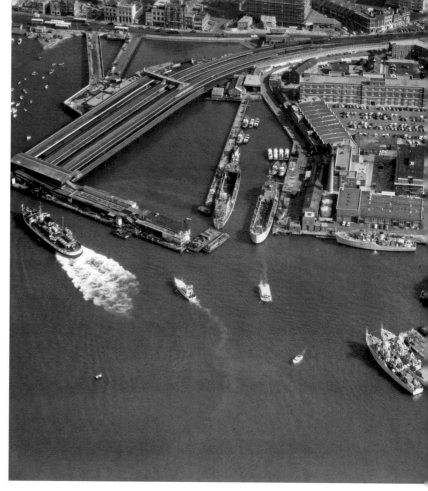

Portsmouth Harbour Station
Portsmouth Harbour Station, seen here in 2017, is built out into the harbour on a wooden pier that was greatly damaged during the Second World War. The 170m-high Spinnaker Tower (completed in 2005), located in the nearby Gunwharf Quays shopping complex, overshadows the station on the right of the photograph, while close by the entrance to the station (further to the left) is the bus interchange, which, at the time of this photograph, was undergoing reconstruction.

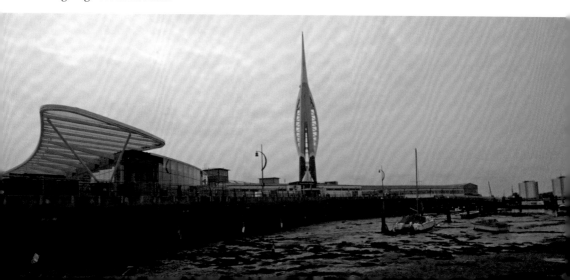

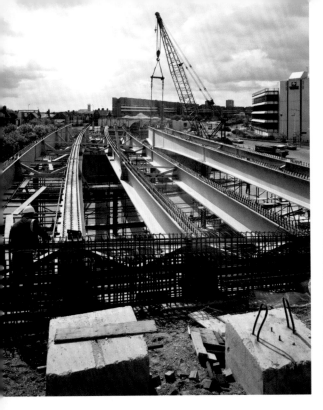

Construction of the M275 Flyover at the Rudmore Roundabout
Since its completion in 1976, the M275 has become the main entry route into Portsmouth. In 1987, further work was undertaken on the motorway with the construction of the M275 flyover at the Rudmore roundabout to reduce congestion by allowing traffic for the city centre to go straight over. Taken on 11 May 1987, this picture shows beams being put in place for this work on the flyover.

Construction of the M275 Flyover at the Rudmore Roundabout
A second view, this one taken at night, showing the placing of beams as part of the construction of the M275 flyover at the Rudmore roundabout. Being 740 metres in length, starting at a point on the M275 270 metres north-west of Rudmore roundabout, the flyover proceeds in a generally south-easterly direction to pass over Rudmore roundabout and ending at a point 350 metres to the south.

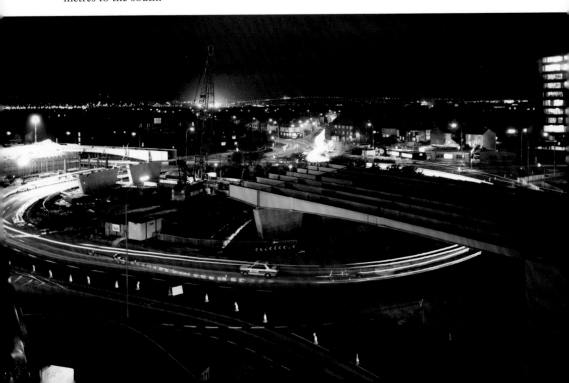

The Historic Dockyard

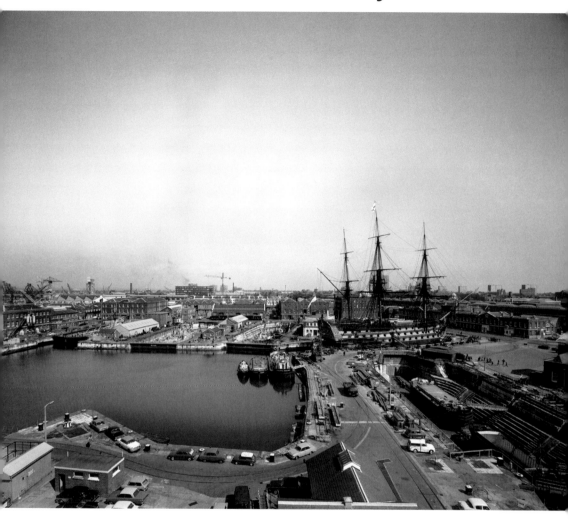

An Elevated View Looking East Across Nos 1–5 Docks and Showing HMS *Victory*
A major attraction for tourists arriving in Portsmouth, be it by car, ferry, bus or train, is the Historic Dockyard with its various historic ships and museums. This elevated view, dating to 1971, looks east across Nos 1–5 Docks and shows HMS *Victory* in her dry dock. One of the world's most famous warships, *Victory* has been a major visitor attraction, with approximately 400,000 visiting her each year, gaining a unique glimpse into the conditions of life at sea during the time when sail predominated.

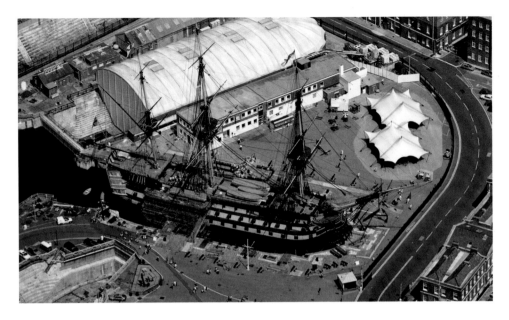

HMS *Victory*, Portsmouth Historic Dockyard, 1995
Launched at Chatham in 1765, HMS *Victory* counts as the oldest commissioned ship in the world, currently serving as the flagship of the First Sea Lord, although the ship herself has, since March 2012, fallen into the ownership of HMS Victory Preservation Trust, which is part of the National Museum of the Royal Navy. A tradition on each 21 October – this being the date of the Battle of Trafalgar, which was fought in 1805 – is to fly Nelson's famous signal: 'England expects that every man will do his duty.'

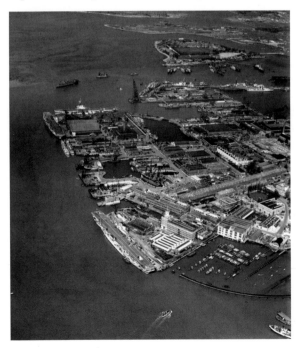

Portsmouth Historic Dockyard and Environs, Portsmouth, 1951
A more general view of the naval dockyard taken from the air on 6 April 1951, when the only real dockyard attraction was HMS *Victory*, seen clearly at the centre of this photograph. Most of the historic part of the yard was still in the hands of the Admiralty, and responsible for fitting and refitting a much larger number of ships than now enter the yard. Note, for instance, the three aircraft carriers (HMS *Indomitable* is nearest to the camera) moored alongside the dockyard and taking up the entire length of Watering Island and Middle Slip (now Princess Royal) Jetty.

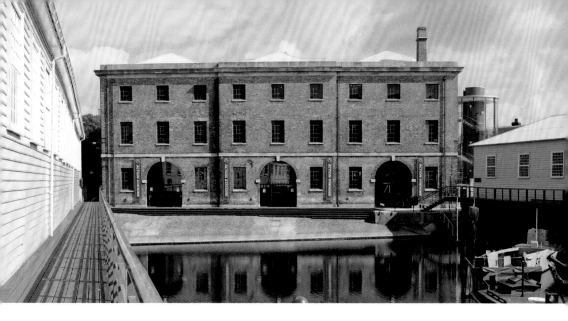

Exterior General View of Boathouse
Among the many attractions drawing large crowds into the Historic Dockyard is 'Action Stations' housed in No. 6 Boathouse, the building at the far end of this stretch of water that was first used for storing mast timbers – it was later converted to use as a basin for the holding of steam pinnaces of the fleet. Easily found, as the boathouse lies close by Victory Gate, with this photograph taken in October 2001, 'Action Stations' sets out to give a taste of life in the modern-day Royal Navy through interactive adventure.

No. 6 Boathouse, Naval Dockyard Heritage Area, College Road
Interior view of No. 6 Boathouse, which was converted to its present use as an exhibition centre at the beginning of the century, receiving a Civic Trust award in 2002.
A Grade II-listed building that dates to 1846, it was severely damaged during the Second World War. The challenge for MJP Architects, who were given the task of converting the building, was working within the constraints of the existing building while respecting and complementing its original construction and fabric. For this purpose, all newly installed architectural elements were made reversible, allowing the original architecture and the new insertions to be read separately while avoiding any damage to the existing fabric.

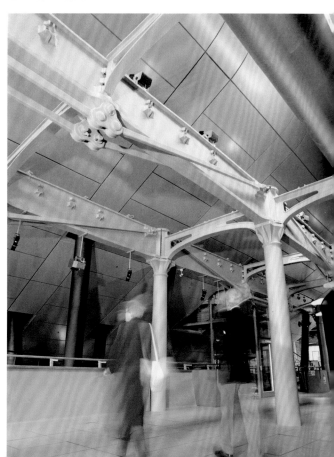

Small Dock Interior

Boathouse No. 4 is also located close to the main point of entry into the Historic Dockyard and was also once used for maintaining and repairing the small boats of the fleet. Built immediately prior to the outbreak of the Second World War, it had the addition of a small dock built into the structure of the building to allow boats to be brought directly into the boathouse rather than being pulled up onto dry land. So, despite this appearing to be a view somewhere outside the building, it is actually a photograph taken inside the building.

Small Dock Interior
A further view of the small dock inside Boathouse No. 4, with this and the preceding photograph both taken in July 1997. Now a visitor attraction, Boathouse No. 4 houses an exhibition entitled 'The Forgotten Craft', which tells the story of the small boats that were once so important to the Royal Navy. It includes the wooden cutters that ferried Lord Nelson to his flagship as well as the much later canoes of the 'Cockleshell Heroes'.

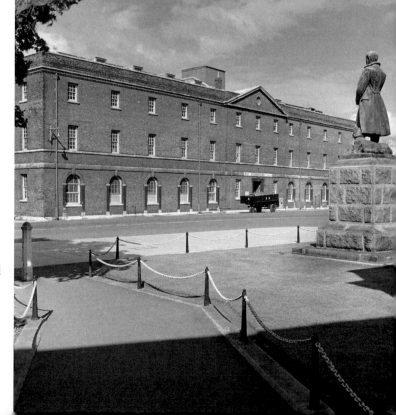

No. 11 Storehouse
A general view, dating to 1956, of No. 11 Storehouse with a statue of Captain Scott in the foreground. This building is now part of the National Museum of the Royal Navy, another major attraction located within the Historic Dockyard.

No. 11 Storehouse
A more detailed view of No. 11 Storehouse. This photograph was also taken in 1956. No. 11 Storehouse was one of three large storehouses built during a dockyard expansion programme carried out during the mid- to late eighteenth century. Suffering a major fire in 1874, it was completely gutted, but was successfully refurbished a few years later as a result of its outer walls having remained intact.

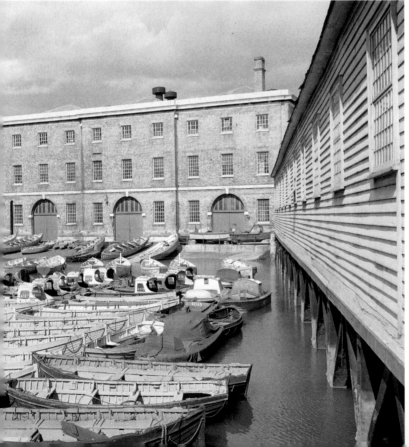

General View of a Boathouse at Portsmouth Naval Dockyard, Looking Across the Dock
A further photograph from 1956, this shows the No. 6 Boathouse at a time when it was still required by the dockyard together with the basin that fronts the building, a former mast pond and used at that time for the holding of small boats belonging to the fleet.

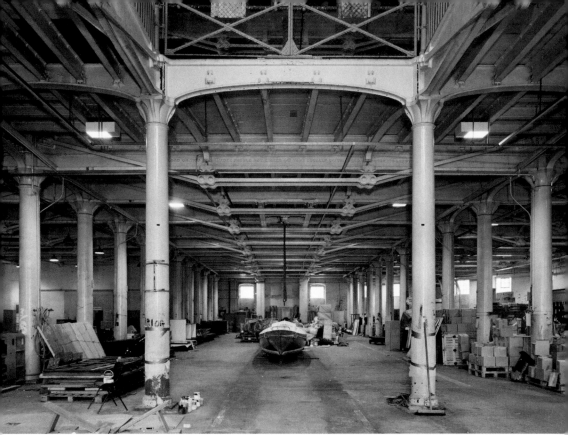

Above: Interior of Boathouse No. 6 – from the West
An interior view of No. 6 Boathouse, this dating to 1991 and showing the building before work had begun on its conversion into an exhibition centre by MJP Architects.

Right: Interior of Boathouse No. 7 – from the North-west
Boathouse No. 7, as seen in June 1991. Once used for the storage and repair of small boats, this is another building that now plays an essential role within the Historic Dockyard, having now taken on the dual role of restaurant and gift shop.

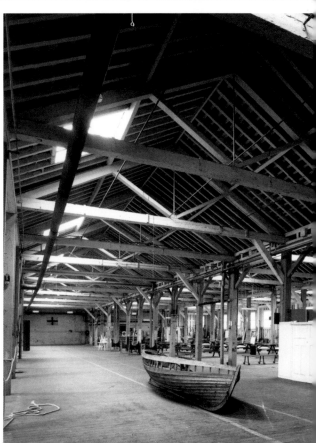

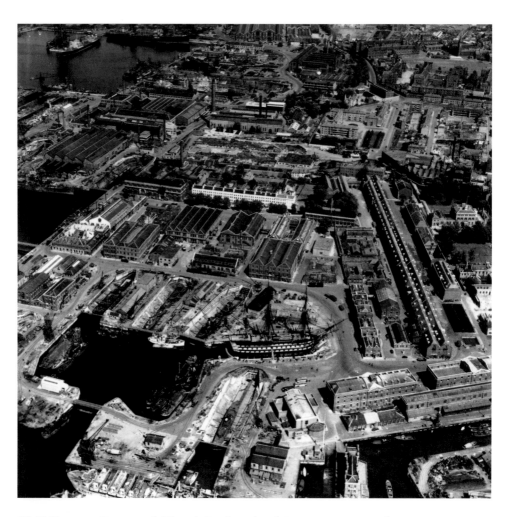

HMS *Victory* at Portsmouth Historic Dockyard and Environs, Portsmouth, 1949
A further aerial view of the dockyard, this dating to 1949, with part of the historic yard visible together with *Victory*. Next to *Victory*'s stern is a large area of water that was once known as 'the Great Basin' and which, itself, is of considerable historic interest. As built in the 1690s, its purpose was to allow warships to be equipped more conveniently than they would be in the open waters of the adjoining harbour. Enlarged between 1796 and 1805, it was at that time provided with two additional docks, the basin having been given a dry dock at the time of its original construction and a second during the 1770s.

Old Portsmouth and Beyond

Gunwharf
Following in the footsteps of an imaginary tourist to Portsmouth (whether arriving by train, ferry or car), time in the Historic Dockyard should be followed by a visit to Gunwharf Quays, a recently developed shopping centre. This, too, has considerable historic interest, for it was originally a facility designed to store and repair naval ordnance. In this respect, it worked closely with the dockyard as, during the age of sail, cannons had to be offloaded from ships before they could be dry docked. Newly launched warships, or those leaving the dockyard, would receive from the Gunwharf the guns and ammunition they required before proceeding to sea.

Gunwharf

A number of buildings from the original and historic Gunwharf have been retained and restored. Among them is this early nineteenth-century building that began life as a storekeeper's office and has now been converted into a bar and restaurant.

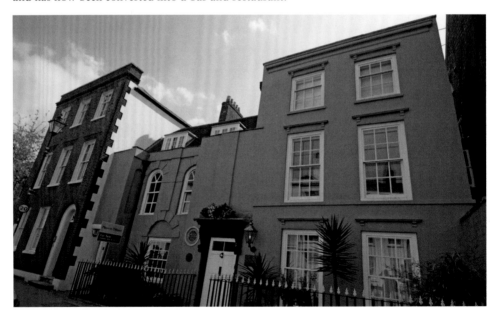

Buckingham House

On passing along St George's Road with the United Services Ground to the left, High Street will soon be reached, this a not-to-be-missed road with a collection of historic buildings that form part of Old Portsmouth. One building of particular interest is No. 10 in the High Street, a former public house now known as Buckingham House. It is one of the earliest domestic buildings within the city, having an internal timber-framed structure dating to the sixteenth century.

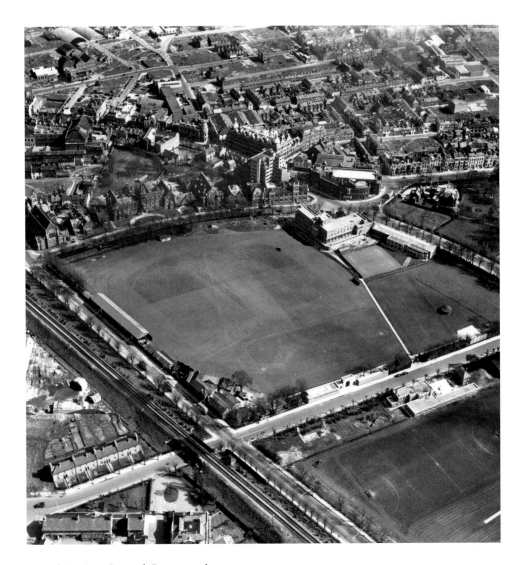

United Services Ground, Portsmouth

On leaving Gunwharf Quays, a visitor intent on following an historical theme might well head for Old Portsmouth, with its numerous ancient buildings. To do so, the walk from Gunwharf Quays runs alongside a sport's ground – the United Services Recreation Ground. This is clearly seen in this aerial photograph dating to 1951. Established during the mid-nineteenth century, the United Services Recreation Ground was once a venue for first-class cricket – Hampshire playing regular matches there – but was finally abandoned in 2000 because of the poor quality of the pitch. Currently, both the United Services Portsmouth Rugby Football Club and the Royal Navy Rugby Union use the ground for home matches. In the aerial photograph, on the road to the left of the ground, traffic includes a couple of trolleybuses, a system of transport that began in Portsmouth during the 1930s and continued until July 1963.

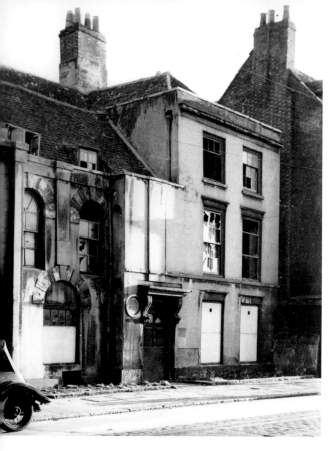

Exterior View, from the North-east, of Buckingham House after it Had Been Damaged in an Air Raid
This photograph shows Buckingham House in less happy times, much damaged in 1941 during a night bombing raid mounted by the German Luftwaffe. Restored after the war, many of the original features have been preserved, the house receiving Grade II*-listed status in 1953 as a building of special architectural and historic importance.

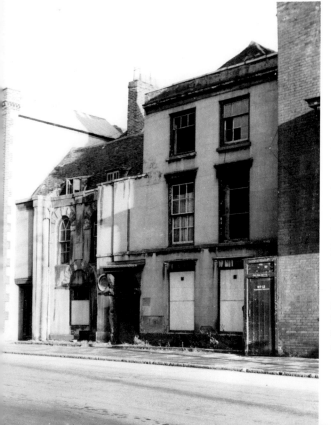

Exterior View, from the West, of the Bomb-damaged Buckingham House
A further view of Buckingham House showing the damage sustained during the air raid of 1941. As well as being one of Portsmouth's oldest buildings, Buckingham House has historic importance. Here on 23 August 1628, when it was a public house with upper rooms giving accommodation, George Villiers, the first Duke of Buckingham, was murdered. A former favourite of James I, he had subsequently gained notoriety as an incompetent military commander, with his assassination popularly acclaimed in certain quarters.

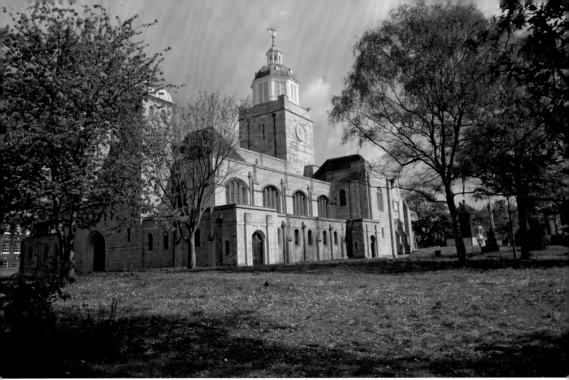

Above: Portsmouth Cathedral, May 2017
Also in this part of Old Portsmouth is the Cathedral of St Thomas, the medieval town church that became a cathedral in 1927. Founded during the late twelfth century, only the chancel and transepts remain from this period.

Right: The Byzantine-style Addition to the Nave in Portsmouth Cathedral
A view of the nave of Portsmouth Cathedral as seen sometime during the middle of the twentieth century. The nave, together with the tower, were both severely damaged during the English Civil War and rebuilt in the classical style towards the end of the seventeenth century.

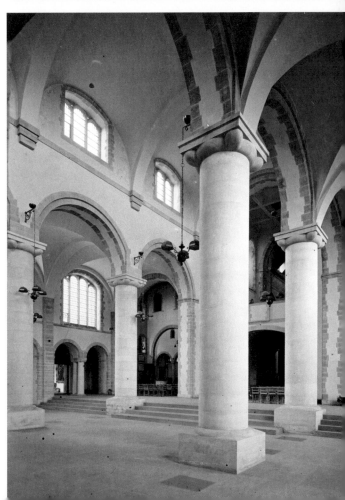

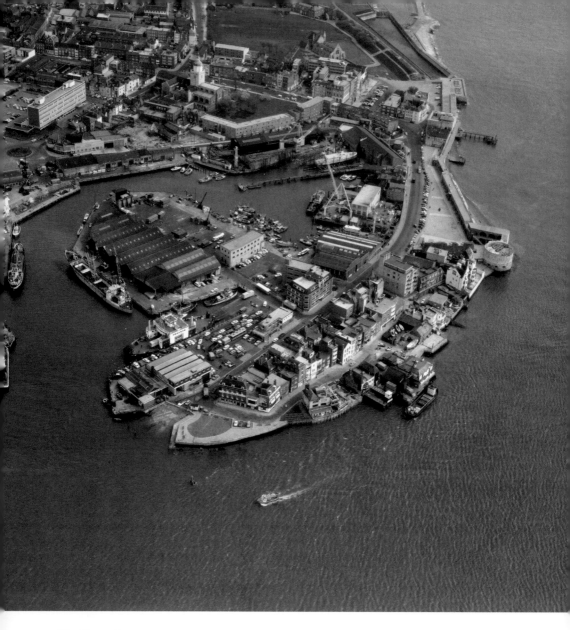

The Town Quay

A wide-ranging aerial view of the environs of Old Portsmouth as seen in April 1972. At top centre of the photograph can be seen the cathedral and part of the High Street, with the Point dominating the lower part of the photograph. Portsmouth Point, during the age of fighting sail, had a particularly unenviable reputation for lewd and lascivious behaviour, a magnet for the sailors of the fleet. Also in this aerial view are the original defences – the walls, known as the hot walls – providing a pleasant walk that takes in the round tower (extreme centre right of photograph) originally built in 1415 and the square tower (extreme right top) originally built in 1494, which adjoins the Saluting Platform of 1568.

Sunny Southsea

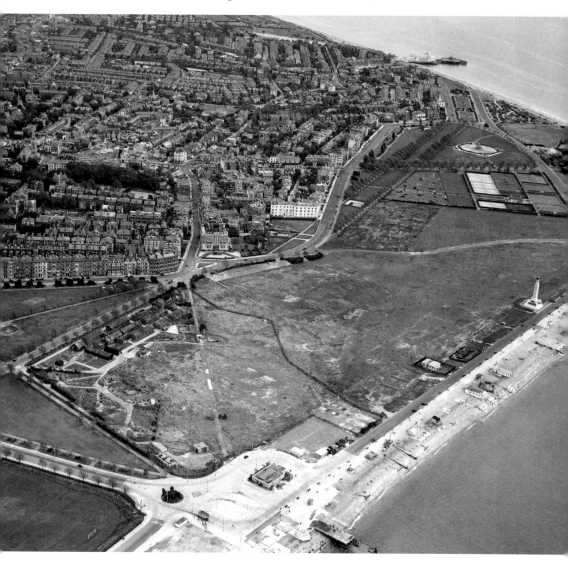

Southsea Common, Southsea, 1946

Having spent a studious day looking at the historic sites in and around Old Portsmouth, it's time to relax in sunny Southsea, a welcoming seaside resort adjoining the bustling city of Portsmouth. From Old Portsmouth, Southsea Common is within easy reach, seen here from the air in October 1946. Stretching from Clarence Pier to Southsea Castle, this large area of open ground was, during the nineteenth century, viewed as important for providing a field of fire if the town was attacked from the sea. In 1922 it was purchased by the council and laid out with gardens, bowling greens and tennis courts. During the Second World War, the Clarence Pier end of the Common housed a heavy anti-aircraft battery.

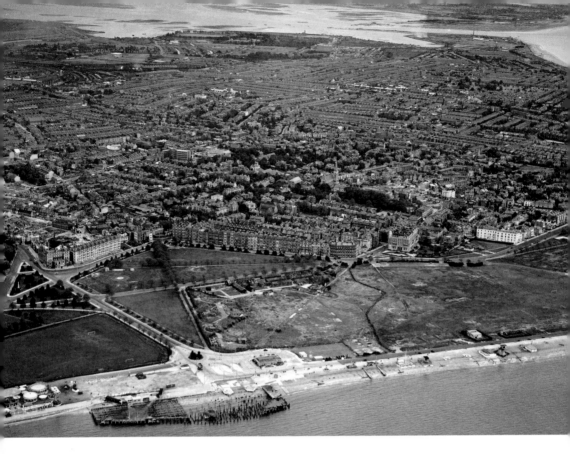

Above: Clarence Pier, Southsea Common, 1946
A more wide-sweeping aerial view of the Southsea Common area. A major point of interest is Clarence Pier (lower centre left) showing air-raid damage received during the Second World War. Originally opened in 1861 for steamers crossing over to Ryde, it was to be rebuilt after the war, finally reopening in 1961 but without any projection into the sea.

Below: Looking North-west Across the Water Towards Southsea Castle
At the far end of the Common is Southsea Castle, as seen here from the south-east in this mid- to late nineteenth-century photograph. Built during the reign of Henry VIII for coastal defence, it was frequently modified over the years, especially at the time of the threatened French invasion when Napoleon was emperor. A visitor attraction nowadays, it houses a small military museum, which gives us the chance to appreciate how the art of fortification building developed from the Tudor to the Georgian period.

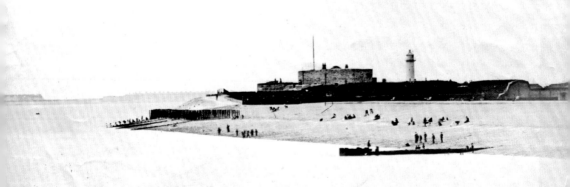

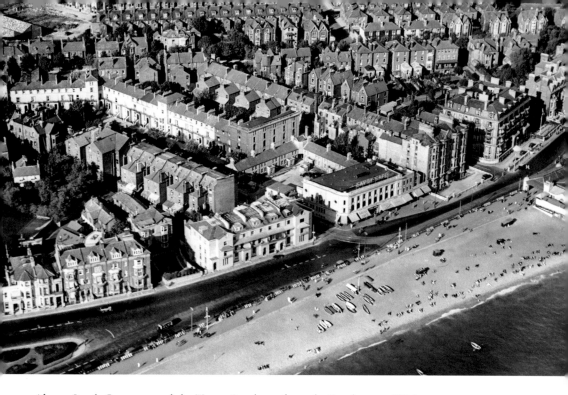

Above: South Common and the Town, Southsea, from the South-west, 1928
A further aerial view of Southsea as seen here from the south-west in 1928. It was during this year that the Rock Gardens were laid out. With Portsmouth Corporation having provided £3,500 for the project, it was to become the largest such garden along the south coast, transforming an area of beach shingle close by Southsea Castle into an attractive sunken garden. Part of a government-supported work scheme, those employed on the task were primarily drawn from among the unskilled and unemployed of the area.

Below: A View from the Beach Looking Towards South Parade, Southsea
South Parade Pier was officially opened in 1879, but was rebuilt and reopened in 1908 following a fire. It was sometime during that same period that this photograph was taken, the photographer having his back to the pier and capturing a general view of the beach and the fine set of houses facing the beach and located alongside the Esplanade.

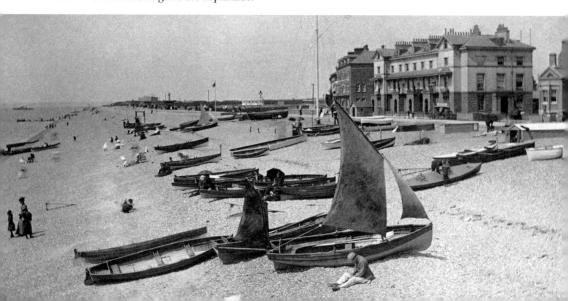

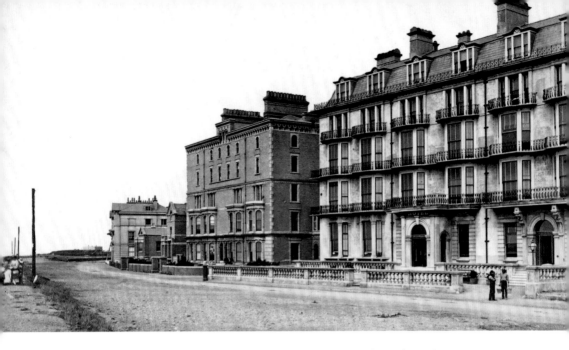

Above: View of Beach Mansions Hotel on South Parade, Southsea, from the East
A view taken in 1877 of the Beach Mansions Hotel (now the Royal Beach). The building was constructed in 1866 and stands immediately opposite South Parade Pier.

Below: General View from the Gardens
The gardens, with South Parade Pier forming a more distant backdrop. The juxtapositioning of the two is interesting, providing the contrast as presented by these two features of the Southsea seaside resort in its heyday. The pier offers brash sensational-style entertainment for the holidaymaker, while the carefully thought-out gardens offer near-perfect tranquillity. The Rock Gardens are located nearby, of which this is really an extension, the large limestone blocks here informally laid out to provide all-year-round protected seclusion that enabled, and continues to enable, alpine shrubs and lawns to prosper throughout the year.

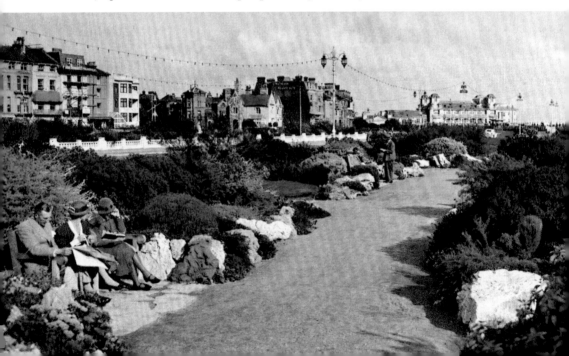

Above: Clarence Parade
A pre-Second World War view of Clarence Parade with Southsea Common to the right. A few changes are discernible, but the view today is not so different.

Below: South Parade Pier and the Town, Southsea, from the South, 1928
South Parade Pier and Southsea viewed here from the south in September 1928. Following the serious fire that had destroyed the first pier, a new pier was built in 1904 at a cost of £85,000. With a length of 600ft, it possessed a spacious pavilion containing two halls, one a 1,200-seat theatre and the other a cafe during the day and a dance hall at night, while at the seaward end there was a separate pavilion with a bar and lounge.

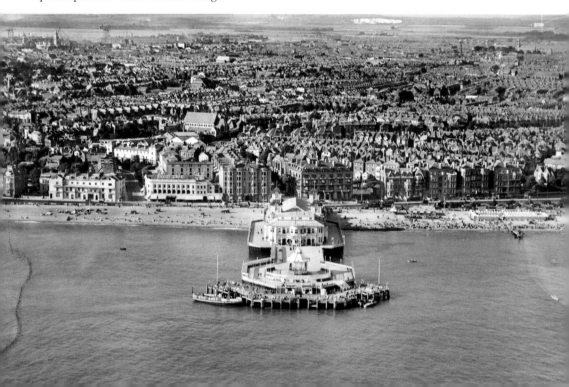

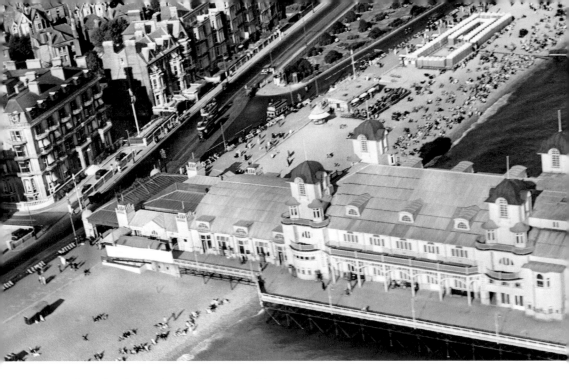

Above: South Parade Pier, Southsea, 1928
South Parade Pier in September 1928 with the aerial photographer closing in upon the pavilion at landward end with its 1,200-seat theatre. The summer season has now peaked but the theatre was still providing regular entertainment by engaging a number of touring acts that went from one seaside town to another. During the summer of 1928, a series of musical acts and sketches had proved especially popular, together with a series of light plays that were shown each evening with weekend and midweek matinee performances.

Below: General View of People by the Lake
Canoe Lake seen here shortly before the outbreak of the Second World War. Then, as now, it's a popular piece of water for children, and others, with their model boats. The surrounding park was set out for visitors in 1886, with various additional improvements made over the years. Adding to the attraction of the park and lake is its resident swans, with up to sixty juveniles said to congregate here 'for comfort and security during the winter'.

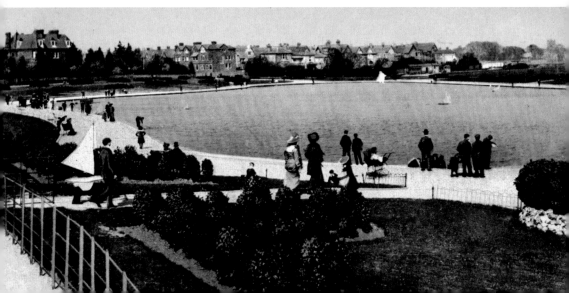

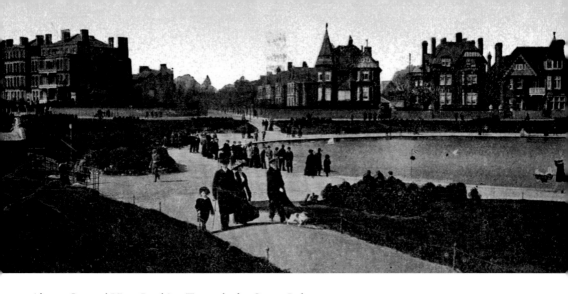

Above: General View Looking Towards the Canoe Lake
A further, and possibly earlier, view of Canoe Lake. The large collection of Victorian houses of St Helen's Parade on the landward side of the park possibly indicate the popularity of Southsea as a residence for more affluent members of the middle class.

Below: The Canoe Lake, Southsea, 1928
Canoe Lake as seen from the air in September 1928. Hiring boats to go out on the lake was as popular then as it is now, with the boats hired at that time appearing to be a choice of canoe or larger rowing boat. As with today, a popular restaurant existed on the east side of the park. Part of Festing Road is to be glimpsed in the top right-hand corner of the photograph.

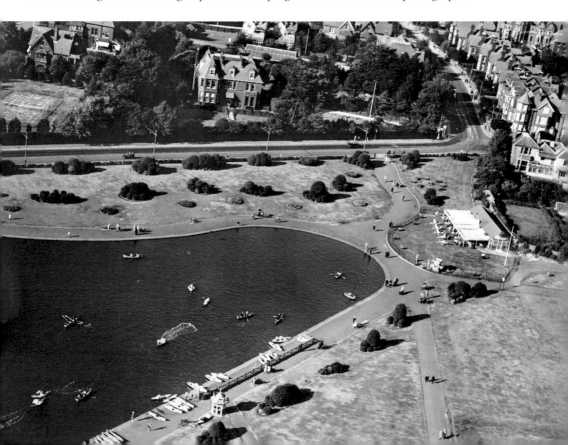

General View of the Emmanuel Emmanuel Memorial Drinking Fountain, from the North-east
To the west side of Canoe Lake is located this memorial to Emmanuel Emmanuel, the first
Jewish mayor of Portsmouth, holding office in 1866–67. He is not only representative of the
important contribution made in the civic life of Portsmouth by the local Jewish community,
but the considerable contribution made by many other minority group members as well, some
of whose achievements are celebrated in an earlier publication written by the author of this
book, entitled *Settlers, Visitors and Asylum Seekers: Diversity in Portsmouth since the late
18th Century.*

The Rock Gardens, Clarence Parade and Environs, Southsea, 1946
The Rock Gardens as seen from the air in October 1946. Less than a year and a half since the war in Europe had come to an end, the resort has still not been fully prepared for holidaymakers, part of the neighbouring common covered with military Nissan huts serving as emergency housing for those bombed out of their homes, while the Rock Garden appears to be in need of some loving care and attention. Although Southsea did recover from the damage of the war, it was never to regain the popularity it had possessed in the years before it.

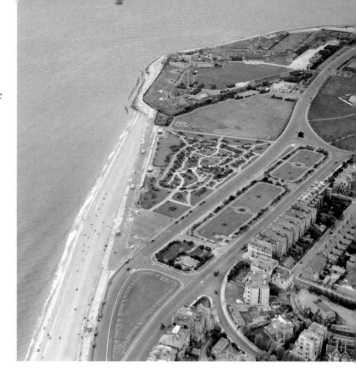

General View of Crowds of People
Lady's Mile sometime around 1900. A tree-lined footpath was formed from a double avenue of elms running in a north-westward direction from Avenue de Caen. Stretching across the Common and parallel to the seafront, this was a popular place during Victorian times for a gentle summer's walk; indeed, it was the fashionable place to be seen, especially if you could afford the latest summer finery. With the Common leased from the War Department by Portsmouth Council in 1884 (but not purchased until 1922), Lady's Mile was laid out shortly afterwards.

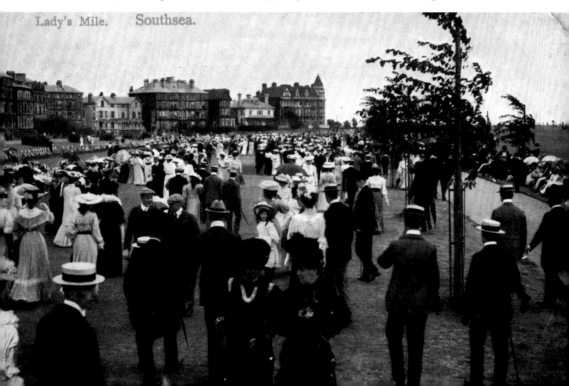

Lady's Mile. Southsea.

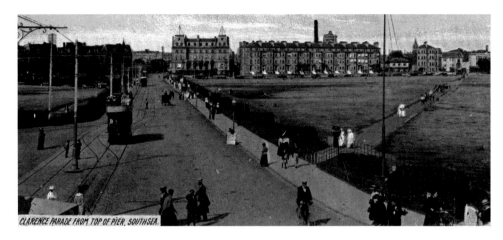

CLARENCE PARADE FROM TOP OF PIER, SOUTHSEA.

The View of Pier Road and the Common from the Top of the Pier
An Edwardian period postcard showing the road running down to Clarence Pier, which cuts across Southsea Common. The electric tram seen here is in the colours of the Portsmouth Corporation Transport, a company owned by Portsmouth Corporation, and would have been a fairly novel sight at this time. The former horse tram route only converted to electrical power in 1901.

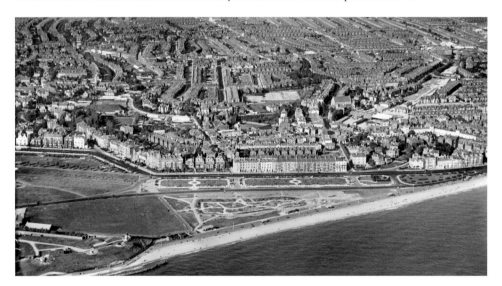

Southsea Common, Southsea, 1946
One final view of Southsea, seen here in October 1946. This picture is set up quite nicely for our journeying visitor to progress on to the shops and other entertainment on offer within the town of Southsea. As can be realised from the aerial view, Southsea, away from the seafront, is a densely packed, extensive development occurring mainly from the mid-nineteenth century onwards. In his Hampshire volume of the 'Buildings of England' series, Nicholas Pevsner simply notes 'there is no architecture whatever of special interest in Southsea, and not much that is worth looking at'. To this he adds, 'but a walk through some of the older parts, with a return along the sea front, is, from the architectural point of view, just worthwhile'.)

Shops and Cinemas

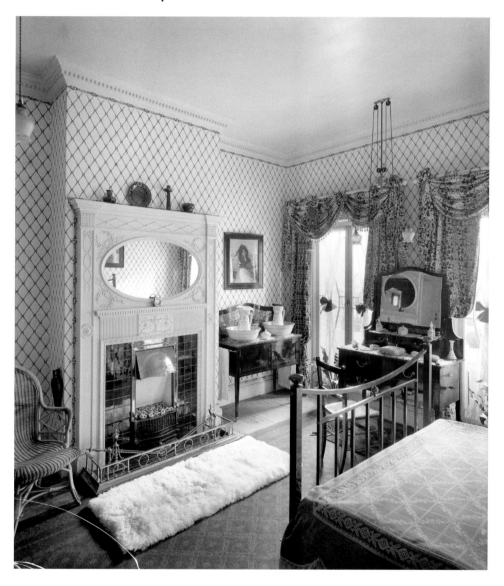

A Showroom Designed as a Bedroom in Handleys Store

Having entered the more compact area of housing in Southsea, some of the larger and more fashionable shops were to be found in Palmerston Road, which lies beyond the Common to the north of Southsea Castle. Among shops to be found here, welcoming tourists in the summer and residents all year round, was Handleys Ltd, a large department store that described itself as 'the largest shop on the south coast'. Occupying a considerable frontage, customers would be entranced by a regular change of displays, with one showroom in 1908 demonstrating the latest ideas for a bedroom design.

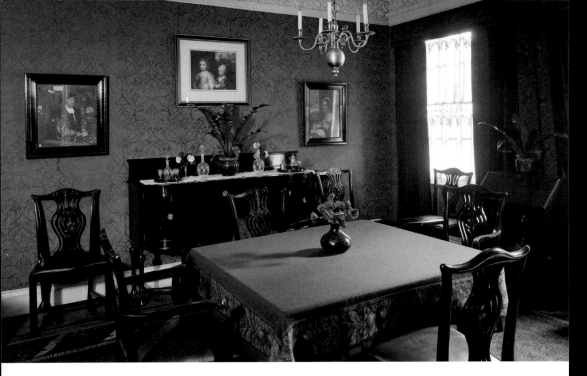

A Showroom Designed as a Dining Room in Handleys Store, Looking Towards the Sideboard Occupying Nos 52–64 Palmerston Road, there was little that Handleys Ltd did not sell. Open six days a week, but closing at 2 p.m. on Saturdays, the store had numerous specialised departments that changed to meet the needs of the season. In May, for instance, a special sun shade department was always opened, this offering 3,000 sunshades to choose from and some of the main designs listed in a special catalogue usually published in the *Portsmouth News*. Undoubtedly, it was the furnishing displays that were always the most lavish, with this showroom demonstrating a design, at a price, for a drawing room.

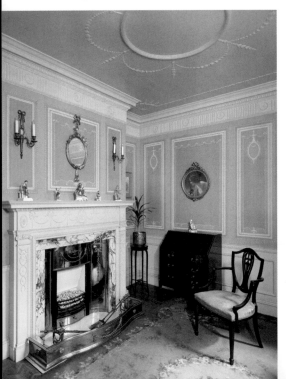

A Showroom Designed as a Drawing Room in Handleys Store

Christmas was always busy at Handleys, not just because it sold Christmas decorations, cards, children's toys and most other desirable objects but for the entertainment provided. In December 1903, the store was advertising a programme of music played on the pianola followed by a programme of music for the gramophone. Here, the Handleys showroom has been set up as a design for a drawing room with the photographer looking towards the desk and fireplace. On 10 January 1941 part of the store was extensively damaged in the same air raid that destroyed Clarence Pier, with the fashion departments transferred in February to No. 41 Osborne Road. After the war a new store (now Debenhams) was built on the original site.

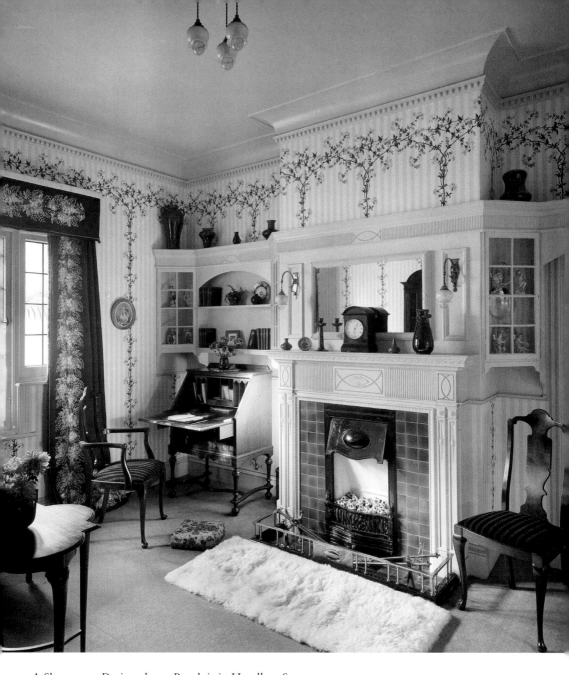

A Showroom Designed as a Boudoir in Handleys Store

In this final glimpse of Handleys in 1908, the department store in Palmerston Road, the showroom displays a design for a boudoir, the photographer looking towards the desk and window. Doubtless, many of the more affluent living in the larger houses on the eastern edge of the town close by the sea, and usually employing one or two maids, would have been tempted to buy these furnishings. As such, they provide a potential insight into the lives of Southsea's middle-class residents, the usually male breadwinner likely to be employed as a military officer, a former high-ranking naval commander or a senior manager in the dockyard.

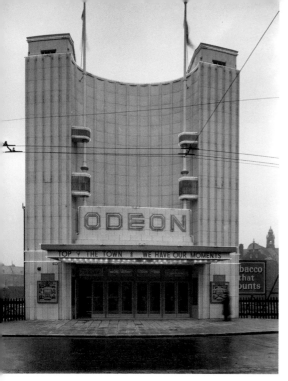

Exterior of the Odeon
A highlight for many visitors to Southsea would be an afternoon or evening at the cinema. The town had several, these aiming, in particular, to catch the summer holiday trade. Most magnificent of those cinemas was the super-cinema on the corner of Festing Road and Albert Road – a super-cinema because it was in its design, size and projection facilities well in advance of most cinemas of the time, although admittedly Portsmouth had more than its share of these new super-cinemas. This one was part of the Odeon Cinema chain as founded by Oscar Deutsch. This is a 1937 photograph taken during the first full week of the cinema's opening. The two films being shown were both American productions: *We Have Our Moments* and *Top of the Town*.

Auditorium
The Festing Road Odeon showing the auditorium from the balcony. This balcony and its approach was in every way luxurious. The staircase was wide and at the top was a crush-proof foyer from which the circle could also be reached. In all, the cinema had capacity for an audience of 1,700. Of those two films shown in the week following its opening, *We Have Our Moments* involved a schoolteacher on a cruise to Europe becoming involved with a gang of crooks and *Top of the Town* was a comedy.

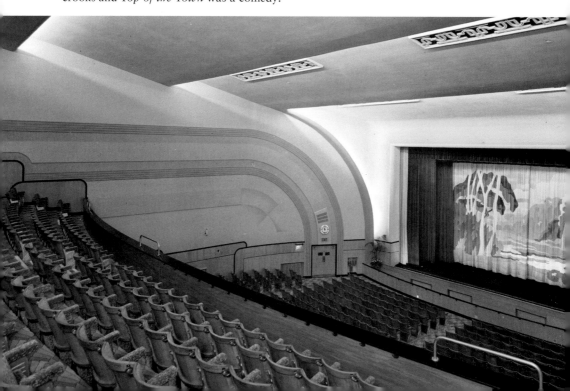

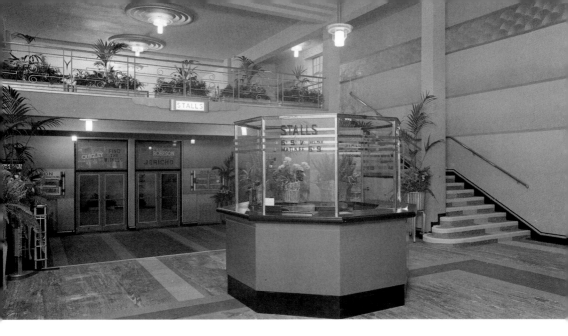

Above: Foyer and Paybox
The large open foyer of the Southsea Odeon allowed queues to form inside rather than outside the cinema while payments for tickets were made at this circular glass island paybox. Officially opened by the Lord Mayor of Portsmouth on 4 December 1937, the Southsea Odeon, in time, fell under new management, becoming the *Salon* in 1977 while in 1981 it was revamped into a two-screen cinema. However, this did not save it from falling audiences, the building closing in 1985 and later being demolished.

Below: Projection Box
A final photograph of the Southsea Odeon at the time of its opening in 1937, this a rare glimpse into the projection box. Here the projection equipment can be seen, which was manufactured by British Thomson Houston. The screen itself was of steel and behind the screen was a large sound chamber.

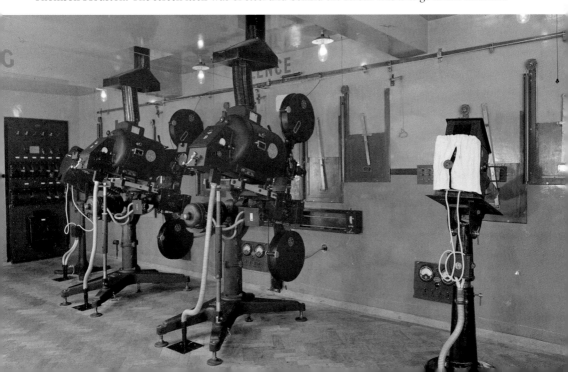

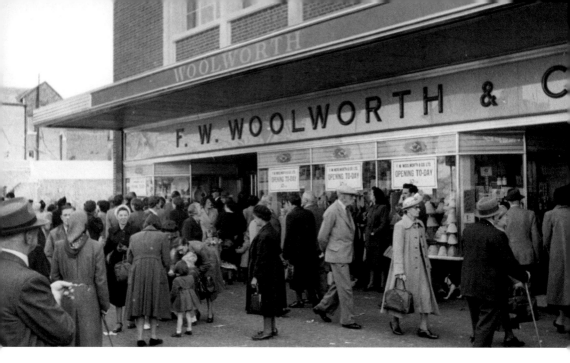

Above: Exterior View Showing Crowds of People Outside the Front of F. W. Woolworth & Co. Ltd, Nos 19–23 Palmerston Road

A new branch of F. W. Woolworth opened in Palmerston Road draws a large crowd, all on the lookout for an opening-day bargain. It is Wednesday 10 October 1951 and the new shop will be opening at 10 a.m. It is the advertised special offers for which this crowd is eagerly awaiting. Previously, Woolworth's had a smaller branch on Elm Grove.

Below: Exterior View of the Front Elevation of the Fratton Branch of F. W. Woolworth & Co. Ltd

While the new Woolworth's on Palmerston Road demonstrated the new style that the company was adopting, a nearby branch in Fratton (No. 98 London Road) still reflected a somewhat dismal 1920s style.

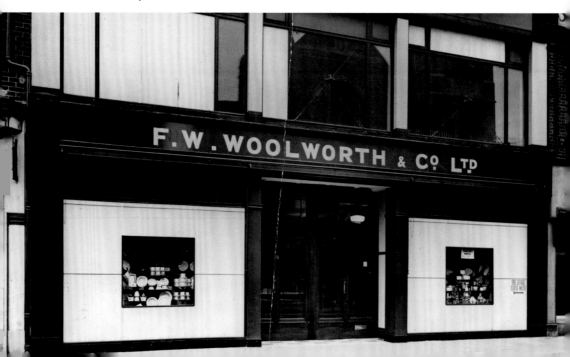

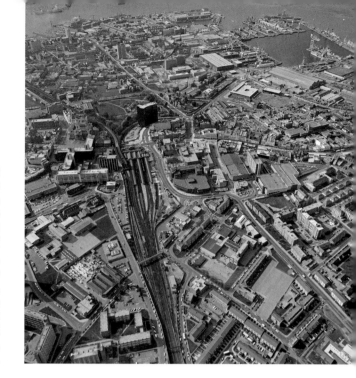

Right: The City Centre and Environs, Portsmouth, 1981
The visitor to Portsmouth having by this time hit some of the shops and cinemas of the town, it seems appropriate to take a look at the more central shopping zone centred on Commercial Road. In this aerial view taken on 16 March 1981, Portsmouth & Southsea station is in the centre of the photograph, with the line running on towards the harbour station, but first passing Victoria Park. Guildhall Square is to the left of the station and Commercial Road on the right.

Below: Shoppers Outside the Premises of F. W. Woolworth & Co. Ltd, Nos 121–127 Commercial Road
Continuing, briefly, with the Woolworth's theme, this is the Commercial Road branch (Nos 121–127) in October 1950. Having reopened on the 26th of that month (the original store destroyed by enemy action during the Second World War), it was the nylons counter that was gathering the biggest queues. Note the upper floor, which was still under construction. On the day that followed its opening, the store was plunged into darkness due to a power cut across all of Commercial Road. For a time, the store was lit entirely by candles!

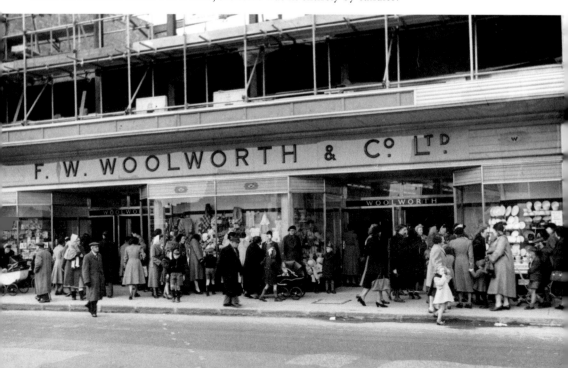

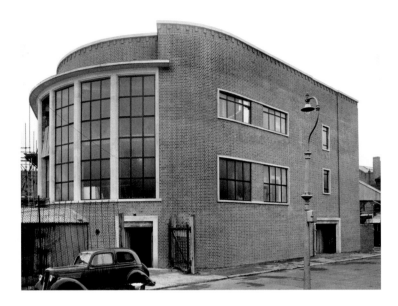

The Rear Elevation of the Commercial Road Branch of Woolworths
A slightly later view, possibly 1952, of the rear of the Commercial Road branch of Woolworth's. For Portsmouth, the reopening of the store brought two advantages. It saw the return of one of the city's most popular stores, and it employed over 100 female assistants (usually aged between sixteen and twenty), helping to reduce the high level of unemployment then current in Portsmouth. Note that in those days the store was free to specify both gender and age when advertising for new staff – a sign of differing times and attitudes.

Commercial Road
Massive damage to the centre of Portsmouth occurred during the years of the Second World War as a result of heavy bombing, with Commercial Road completely redeveloped during the 1950s. Today, Commercial Road continues as a thriving shopping centre with most of the major high street stores to be found along its length.

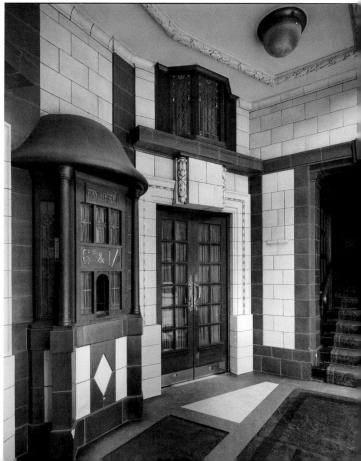

The Entrance to The Picture House

When The Picture House opened in Commercial Road (part of the same building as the Speedwell Hotel) on 16 December 1913, there were a total of twenty-seven picture houses, or cinemas, operating within Portsmouth and all, seemingly, at profit. The first films shown at this new cinema, part of a regular scenario of entertainment that was to include two films and musical entertainment, were *The Bells of Death* (a silent Italian film set in Sicily) and *The Portuguese Centaurs* (a second Italian film, this one demonstrating the abilities of a Portuguese cavalry regiment).

The Vestibule at The Picture House

The entrance front to The Picture House seen here, as with all of the following photographs of The Picture House, dates to April 1915. Owned by the Provincial Cinematograph Theatres Ltd, the vestibule, as seen here, was fitted with decorative marble and had lobbies on either side through which the theatre was reached. The choice of two Italian films for the opening day was in keeping with the declared intentions of the proprietors – that of films shown to be uplifting and directed to such themes as art, history and other more educational matters – with these changed twice a week.

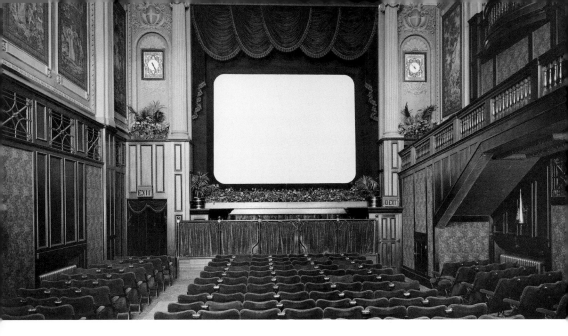

Above: The Interior of The Picture House
The interior of The Picture House, looking from the hall towards the proscenium and screen. Here, with the floor sloping towards the screen, the seating was arranged in three blocks, allowing for an uninterrupted view of the screen. Incorporating a Georgian style of decoration, the hall was enhanced by painted panels depicting various aspects of naval history – clearly very appropriate for Portsmouth. Above the screen and running the length of the proscenium can be seen a panel that contained a painting of Nelson's flagship *Victory*, the work of Norman S. Carr.

Below: The Interior of The Picture House
The balcony itself was reached by a wide staircase leading to the balcony lounge and from where the balcony could be entered. As was now common practice for any new-built cinema, the balcony had tiered seating.

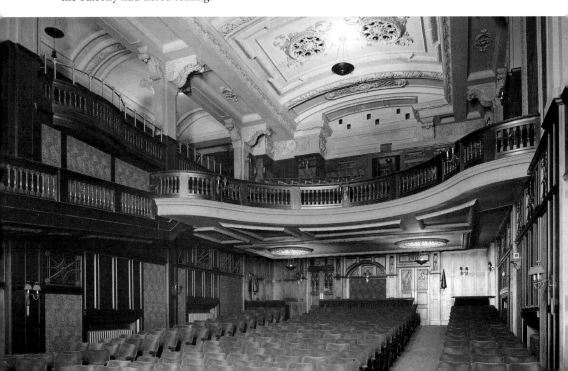

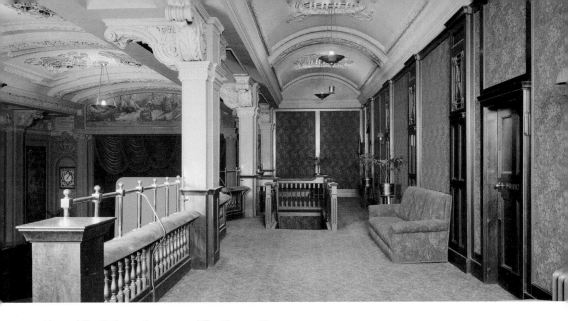

Above: The Balcony Lounge at The Picture House
The balcony lounge at The Picture House, which provided an ample means of exit. Controversy briefly mired The Picture House during the summer of 1915 when accusations were made against the owners – that they 'belonged to or were controlled by alien enemies'. With the country in the midst of war, this was a very serious allegation that not only led to a fulsome denial, but the offering of a £10 reward leading to the apprehension of the person making this 'malicious' statement.

Below: The Switch Room at The Picture House
The projection room at The Picture House. The Picture House no longer exists, hopelessly outdated, and unable to compete with new cinemas of even greater luxury and much-improved projection machinery and able to show the new 'talkies'. It was closed in 1933 and fire damaged the unoccupied building during the following year. Prior to its closure, it had become the Arcade Picture House, with the building demolished in 1936.

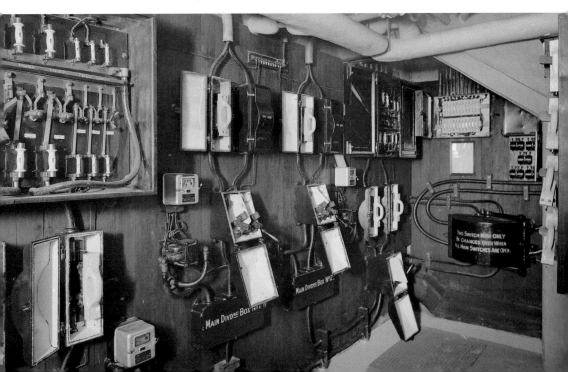

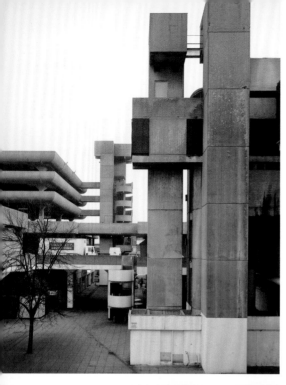

Left: General View of the Tricorn Centre, Showing Elevator Columns, from the West Remaining close to the centre of Portsmouth, this building would at one time have been very familiar to visitors arriving by car. A less than popular structure for many, once voted the third ugliest building in the country, it is the Tricorn Centre. Serving as a car park, the centre also provided space for shops and a nightclub.

Below: Exterior Car Park
Demolished in 2004, this is a further view of the Tricorn Centre and, as with the previous picture, dates to November 1996. Nevertheless, despite the large numbers who pointed to its ugliness, a product of the Brutalist style of architecture, it also had its supporters and, by some, it was much admired, regarded as a monument for its age.

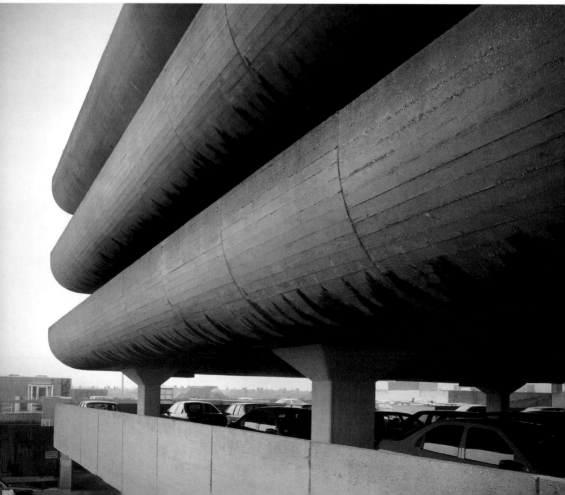

Former Majestic Picture House in Kingston Road

A much larger number of cinemas existed in the North End of Portsmouth, and these aimed to entertain the resident population rather than tourists and visitors. Some of the buildings still remain, among them the former Majestic Picture House. First opened in 1921 with a continuous programme of film that ran from 10.30 in the morning until 10.30 in the evening, it continued showing films until final closure in December 1973. By that time it was operating as The New Classic, having been taken over by Classic Cinemas Ltd, although prior to that it had been the Essoldo.

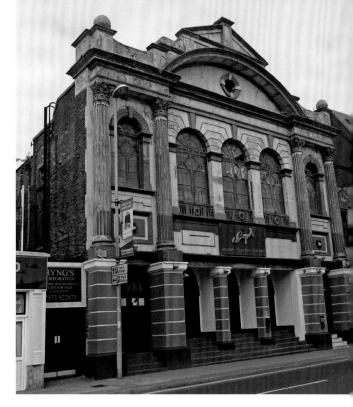

Exterior of the Odeon, London Road

Another of the super-cinemas located in Portsmouth was the Odeon in London Road, opened on 14 December 1936. With a total seating capacity in excess of 1,800, the opening night saw not a vacant seat. The cinema was opened by the Lord Mayor of Portsmouth, and music was provided by the band of the Royal Marines, followed by two hours of films including *Chick* starring Sydney Howard.

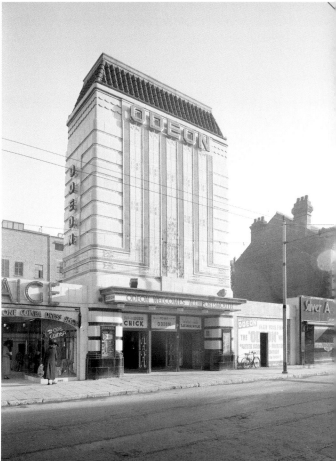

Shaftsbury Cinema
One further former cinema building in North End, now a venue for bingo, is the Shaftesbury Cinema (owned by the Portsmouth Town Cinemas Ltd), which has had a particularly lengthy history, being first opened prior to the First World War.

The Guildhall and Victoria Park

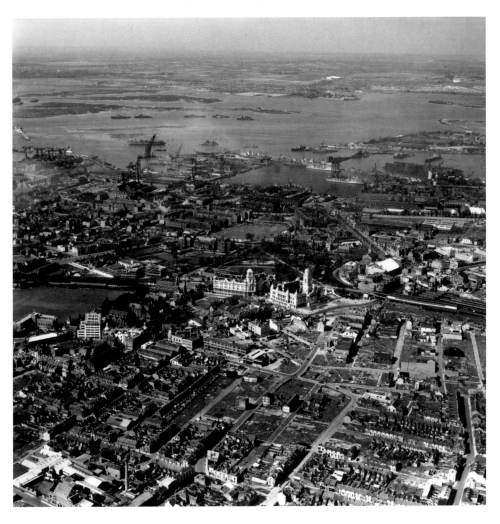

The City Centre and Portsmouth Harbour, Portsmouth, from the South-east, 1951
Perhaps it is time to say goodbye to the visitor and concentrate on those parts of Portsmouth where residents in the city mostly live and work. This aerial view, taken during the first week of April 1951, centres very much on those parts of Portsmouth, with the Guildhall in the centre, Victoria Park nearby and the naval dockyard beyond. The city at that time was still recovering from the war, with many bomb-damaged areas having yet to see any rebuilding. A close examination of the Guildhall will show that it is no more than an empty shell.

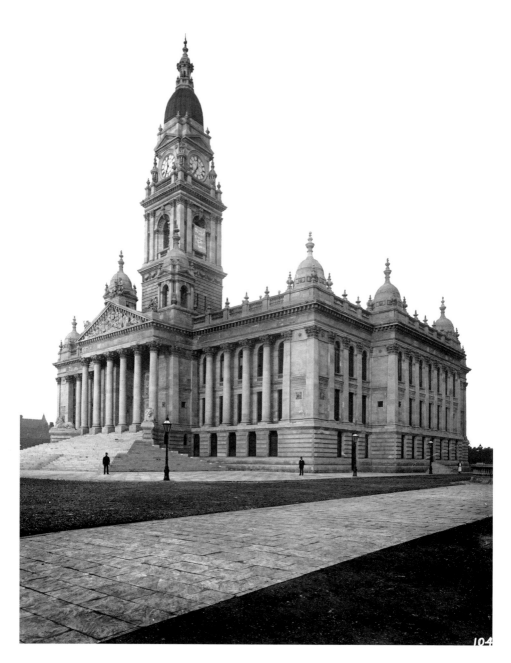

Portsmouth Town Hall Seen from the North Shortly after Completion in 1890
The Guildhall, which stands to the south of Portsmouth & Southsea railway station, is seen
here in 1890, shortly after its completion. The decision to build had been taken in 1879, with
construction work taking place between 1886 and 1890. At the time it was the most impressive
non-military building in the city and certainly dominated the surrounding area.

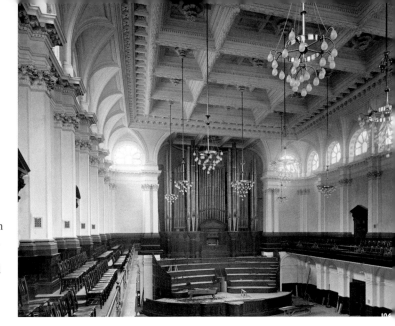

Interior of the Great Hall, Looking Towards the Organ
Interior view of the original Victorian council chamber, which was totally destroyed during the bombing of Portsmouth during the Second World War.

Exterior of the Principal Front of Portsmouth Town Hall
A second picture of the Guildhall taken in 1890 showing the principal front with the grand staircase to the portico. Completely gutted during the Second World War, as can be seen in the aerial picture, it was rebuilt after the war, given a new interior and a restored exterior. However, there were changes to the exterior, this being a simplified version of the original in which the dome and cupola at the top of the tower were not replaced, nor were the corner domes.

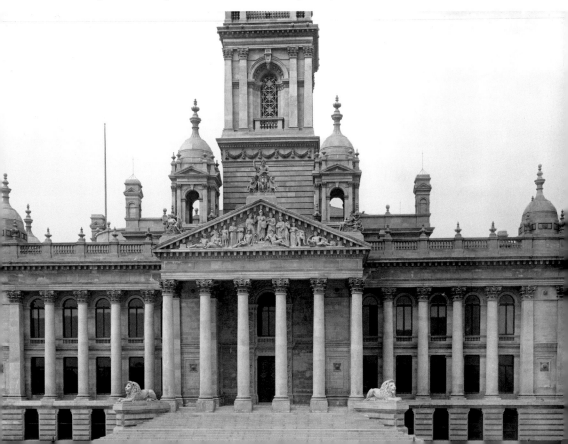

Above: View Showing People Strolling Along the Avenue

A popular park with residents and effectively linking the civic side of Portsmouth with its naval military-industrial complex is Victoria Park just to the north-west of the Guildhall. Opened in May 1878, it has a number of tree-lined walkways and is especially notable for having a number of obelisks memorialising several past naval events involving Portsmouth-based ships and their crews.

Below: Victoria Park Showing the Obelisk Memorial

Victoria Park seen here during the 1920s. Situated immediately north of the Guildhall, it is of some 15 acres in extent. A particular feature of the park is a number of memorials erected by the crews of various naval warships in remembrance of those who died in service. The memorial seen in this picture, and which still stands in the park, is dedicated to the memory of the officers and men of HMS *Shah* who died in the Pacific and Zulu wars.

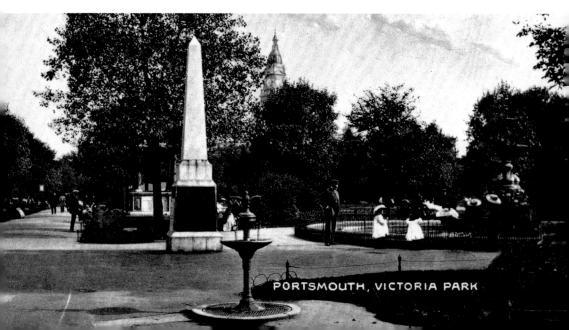

PORTSMOUTH, VICTORIA PARK

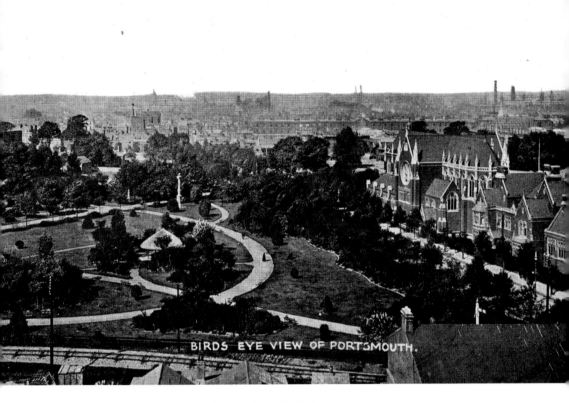

BIRDS EYE VIEW OF PORTSMOUTH.

Birds-eye View Showing Portsmouth from Victoria Park
A further view of Victoria Park with Edinburgh Road on the right. The value of this picture, which possibly dates to the early years of the previous century, is that it shows that an exit at the far end of the park will place us close to the dockyard, the part of the yard that is still heavily engaged in work supporting the modern British Navy.

The Military-Industrial Complex

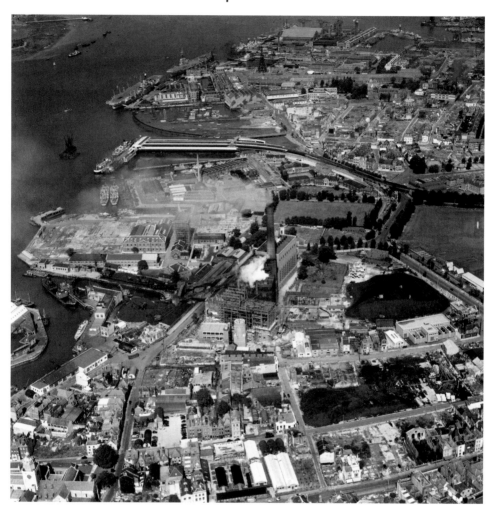

The Power Station and Environs, Portsmouth, 1950

A view taken in 1950, looking across Portsmouth into the dockyard. As of today, the dockyard, now officially HM Naval Base, possesses fifteen stone-built docks, three large basins for the reception of ships, and a complex of buildings that are dedicated to the refitting of naval warships, which includes the recently named Vernon Complex, a primary centre for the navy's eight Hunt Class mine counter-measure vessels. At one time, the entire yard was fully in the hands of the Admiralty; nowadays, while the facilities are government owned, it is private companies, such as BAE Systems, that provide technical and support services, including maintenance, repair and upgrades, to ensure that ships are ready for operational requirements.

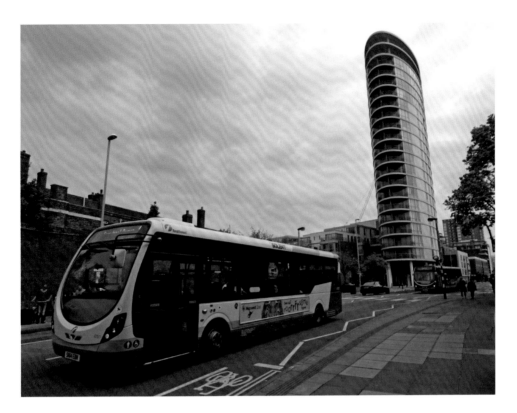

Queen Street
On walking through Victoria Park, the north-west side exits close by Queen Street, the road that runs to the south of the naval base (formerly Portsmouth royal dockyard) and which, during the nineteenth century and early twentieth century, was notorious as a 'red light' area crammed full of pubs to entertain those of the lower deck. Completely redeveloped after the Second World War, its most recent addition is the twenty-two-storey housing tower, the landmark Admiralty Tower, completed in the summer of 2008.

General View of the Ropery Archway at No. 18 Storehouse in Portsmouth Naval Dockyard

While there is a clear distinction between the historic area of the dockyard open to visitors and the working area of the yard, which is very definitely off-limits to the public, there are still a number of historic buildings within the working part of the yard. Among them is the ropery, a building that dates to the late eighteenth century and which continued to produce rope until 1868, when it was converted into a storehouse. This photograph was taken in 1956 and shows an archway that was cut through the building once it ceased manufacturing rope, this allowing movement in the dockyard to take place more easily rather than being taken around this extremely long building.

Exterior Elevation of the Fire Station at Portsmouth Naval Dockyard

Another of the historic buildings within the working area of the naval base, and also photographed in 1956, is the Old Fire Station, which was constructed in 1843. It was designed to accommodate a high-level water tank, supported on girders with the lower part of the building remaining open. The original water tank was removed in 1950 and the sides of the structure filled in. Viewed by one writer as 'a landmark in constructional history', the building has no clear future use as of the time of writing.

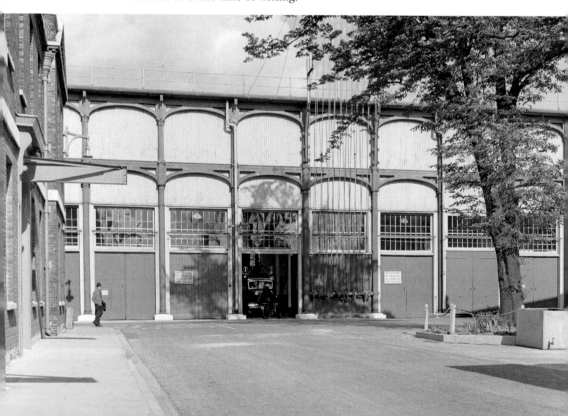

Exterior Elevation of the Fire Station at Portsmouth Naval Dockyard, Showing the Windows
A more detailed view of the Old Fire Station as seen in 1956. Such a building during the nineteenth century was absolutely essential, the risk of fire within the dockyard having rapidly increased due to greater use of steam-powered machinery and the large amounts of combustible material required in the building and repair of warships.

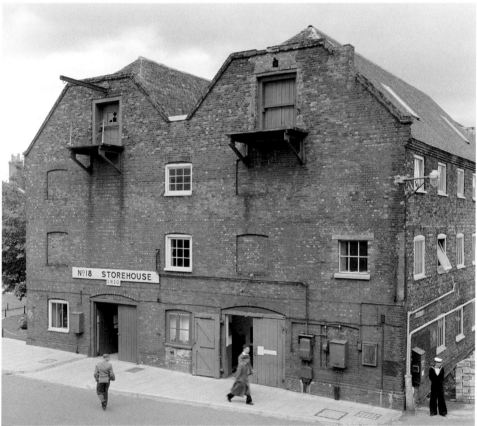

Exterior view of No. 18 Storehouse, Portsmouth Naval Dockyard
This building was formerly the ropery, where rope was spun to rig the fleet and through which the archway was cut once rope making had ceased. This building is fully visible from within the historic part of the yard but, of course, entry is not permitted to members of the public.

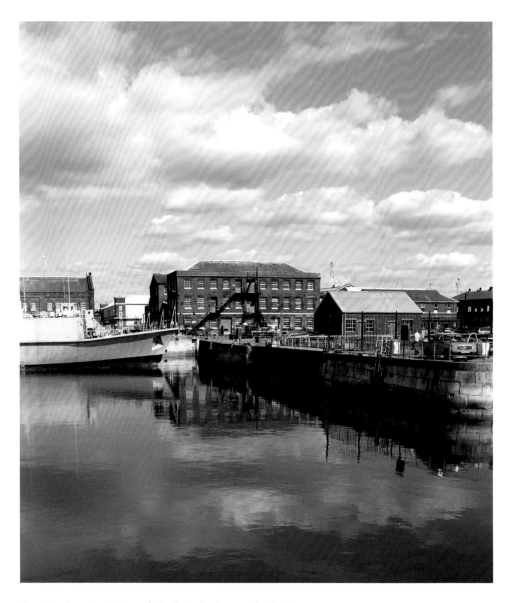

Exterior Location View of Block Mills Across the Basin

This 2005 photograph shows one of the most historically important buildings of the yard remaining within the naval base, as opposed to the historic enclave. This is the block mill designed by Marc Isambard Brunel, which used machinery built by the distinguished engineer Henry Maudslay. The block mill was used to mass-produce blocks used in the rigging of warships, which up until that time had been hand produced. The introduction of machinery to mass-produce blocks was of a truly revolutionary nature as a seventy-four-gun ship of the period required somewhere in the region of 900 pulley blocks with the royal dockyards, in total consuming some 100,000 a year. To produce handmade blocks in such quantity was both time-consuming and expensive, with the introduction of powered machinery soon speeding up the process and ensuring considerable financial saving.

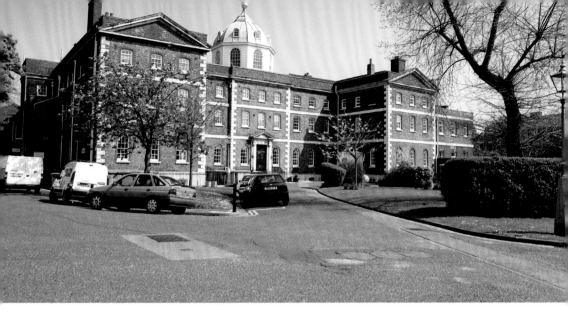

Above: View of the South Elevation of the Old Navigation School
Also dating to the age of fighting sail and in the area of the naval base is the former Naval Academy, a building seen here in 2005. Planned in 1729 and completed in 1733, it originally consisted of a house and school for the boarding and teaching of future naval officers. In time, the academy underwent a number of changes, becoming in 1806 the Royal Naval College, with the building at that time extended to allow attendance of seventy students. It finally closed as a training establishment in 1837. As currently planned, the building will become the main wardroom for naval officers attached to Portsmouth.

Below: Exterior View of Commanders House from the East
The one-time official residence of the admiral superintendent as pictured in April 2005. From 1832 onwards, when the office of admiral superintendent was created, this was the officer placed in overall charge of the yard, superintending the work being carried out through the holding of regular daily meetings with the other senior officers of the yard. The house itself was built during the late 1780s and is now the residence of the second sea lord.

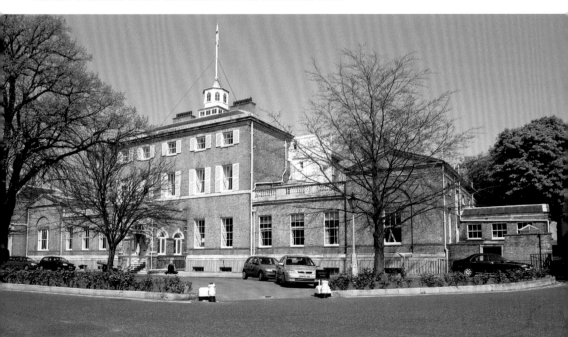

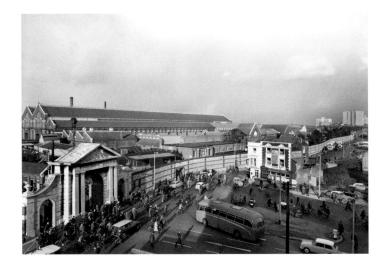

Outmuster at the Unicorn Gate of HM Dockyard
The naval dockyard, as it was when this photograph was taken on 23 October 1964, at the end of the day, with a mass of workers leaving the yard through Unicorn Gate. It was a regular scene that had been witnessed from this gate since the nineteenth century. Unicorn Gate was originally constructed around 1778 as a town entrance into Portsea, but repositioned and rebuilt in the mid-1860s to provide an attractive new entrance into the dockyard.

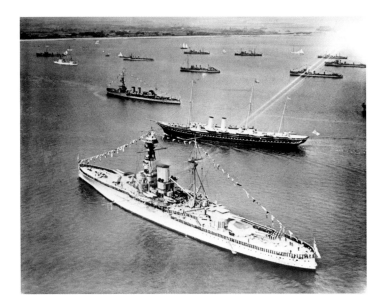

Vessels at the Spithead Review, 1924
The Royal Yacht *Victoria and Albert* with George V on board passes along a line of naval vessels during the fleet review at Spithead on the afternoon of 26 July 1924. Thousands flocked the shoreline of Portsmouth and Southsea to witness the event, which also included an overhead fly-past, an air display and the royal yacht escorted on her return to the dockyard by a number of seaplanes.

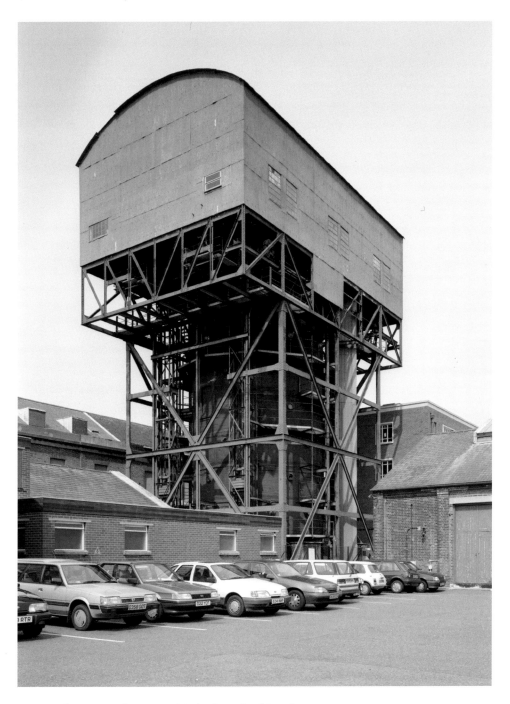

HMS *Nelson*, Deep-diving Test Tank, Gunwharf Road
In May 1994, when this photograph was taken, HMS *Nelson* (Gunwharf) was the naval shore base taking responsibility for training in diving, demolitions and mine warfare. In earlier years, the establishment had been known as HMS *Vernon*.

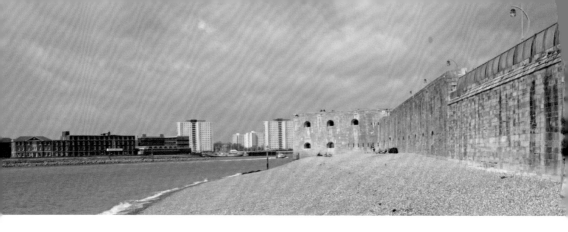

Above: The Hot Walls
The Hot Walls in Old Portsmouth, which stretch between the Square Tower and the Round Tower. All this was part of the early military defences, with some dating back to the fifteenth century. For the visitor to Portsmouth interested in the area's long association with national defence and the navy, the hot walls make an excellent starting point, for it was close to here that Nelson and other sea captains, in the past, left to join their ships anchored in Spithead.

Below: Eastney Barracks, Eastney, 1926
An aerial view of Eastney Royal Marine Barracks seen here in August 1926, at that time home to the Portsmouth Division of the Corps. Built between 1862 and 1867 to a design drawn up by William Scamp of the Admiralty Works Department, the barracks are the major back drop to the popular 1955 war film *The Cockleshell Heroes*. The Cockleshell Heroes used canoes to raid Nazi-occupied Bordeaux in December 1942, targeting the harbour complex of the city. Prior to setting out, most of their training was undertaken in and around Eastney Barracks.

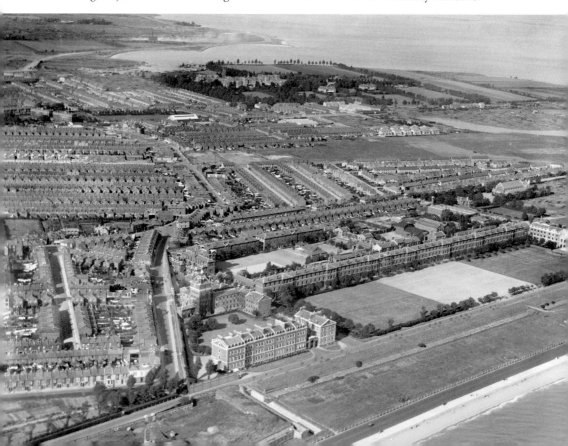

Royal Marines Barracks, Eastney
Nowadays, while most of the complex remains, it no longer houses the Royal Marines, having been sold and converted to private housing in 1995. The strongest remaining connection with the Marines, other than the statue of a Royal Maine on the sea view side, was the Royal Marines Museum established in 1958, but this has recently been moved into the Historic Dockyard.

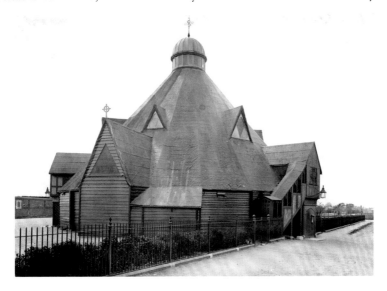

Exterior View of the Crinoline Church at Eastney Barracks
St Andrew's (known as the Crinoline Church) as seen in 1905. Situated in St George's Road, a plaque close to where it once stood suggests that it was originally a field hospital in the Crimea and the structure shipped back to Britain for temporary use as a church. However, this claim has sometimes been questioned, but what is clear is that the building once stood in two previous Portsmouth locations, each time serving as a temporary church, before purchase by the Admiralty to serve the Royal Marines church as the church of St Andrew's prior to the completion of the more solid Henderson Road brick church of St Andrew's built in 1905.

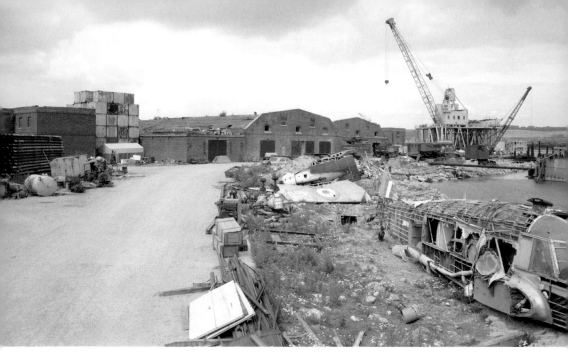

Above: Tipner Magazine
During the 1790s the Board of Ordnance constructed a storage point for gunpowder on the north-west side of Portsea Island at Tipner Point. Two of the magazines (one dating to around 1796–98 and the other to 1856) are still extant and seen here in August 1985. With the area once used as a scrapyard, an interesting collection of disposed military equipment is visible including what appears to be the fuselage of an RAF Avro Anson.

Below: The Victoria Barracks in Southsea
The Victoria Barracks viewed from Pembroke Gardens sometime towards the beginning of the previous century. While this building was demolished in 1967 to make way for a housing development of Pembroke Park, a similar barrack block from the same era, Clarence Barracks, now houses the City Museum in Museum Road.

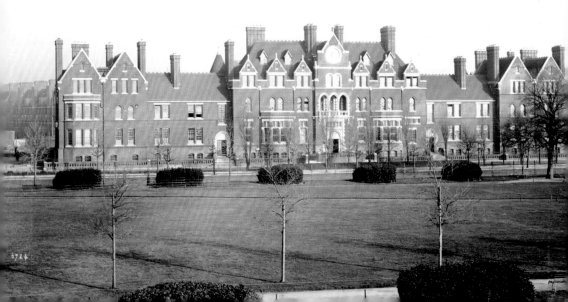

Royal Garrison Church
One of a series of drawings of
the Royal Garrison Church made
in October 1994 and held by
Historic England, this from a
photogrammetric survey sheet
showing the elevation of the
west face. It was originally part
of a hostel founded in 1212 for
pilgrims with a hospital for the sick
and elderly, but after Henry VIII
dissolved the monasteries the
building fell into government hands.
It was not until the mid-eighteenth
century, following a period of
restoration, that it became the
garrison church for regiments of the
Army serving in Portsmouth.

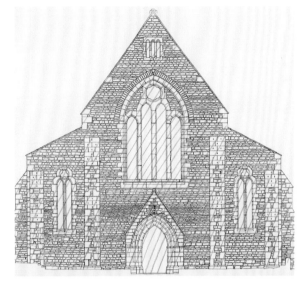

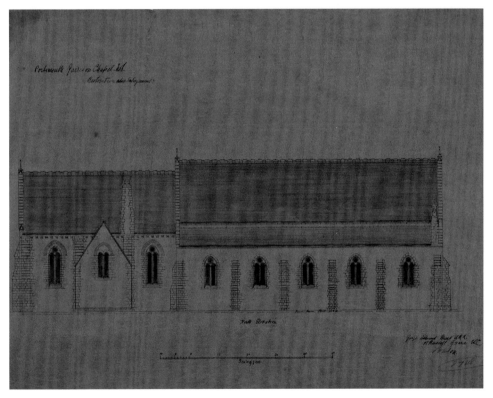

Hand-coloured Labelled Sheet Showing the Royal Garrison Church's North Elevation
A further drawing of the Royal Garrison Church made in October 1994 and held by Historic
England, this one showing the church's north elevation.

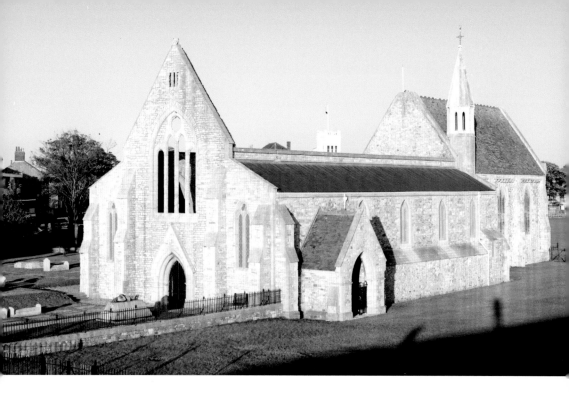

Garrison Church in Evening Light
Nowadays, as can be clearly seen in this 2001 photograph, the garrison church lies roofless, but still much cared for, having suffered considerable damage during a German air raid on Portsmouth during the night of 10 January 1941. Hit by incendiary bombs and a single high-explosive bomb, all the stained-glass windows were destroyed with the loss of the nave roof. However, the chancel was undamaged and is still in use, screened from the nave by a glazed wall.

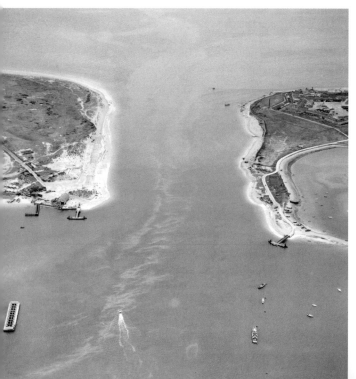

Langstone Channel, Hayling Island, 1946
Another important former military site is Fort Cumberland, which is located on the south-east corner of Portsmouth facing Hayling Island and visible here on the right-hand side of this 1946 aerial photograph. Usefully positioned to defend both the entrance into Langstone Harbour and the sea lane leading into Portsmouth Harbour, Fort Cumberland currently houses the research establishment of Historic England. Originally built during the eighteenth century, it has seen many later additions including a well-preserved High Angle Fire battery of 1890–94.

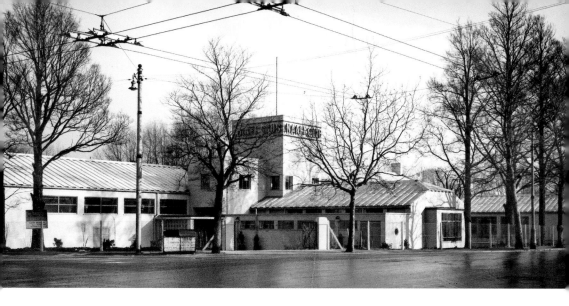

Above: View of the NAAFI Services Club in Portsmouth
The NAAFI Club, Cambridge Junction, in 1946 shortly after it was opened by the then nineteen-year-old heir to the throne, Princess Elizabeth. Officially opened by her on 31 January, the club was built in the grounds of government house, once the residence of the Lieutenant-Governor of Portsmouth, and was the first permanent NAAFI club in the United Kingdom.

Below: View of Services Men and Women in the Canteen of the NAAFI Services Club
Here servicemen and women are photographed in 1946 in the canteen of the NAAFI Services Club in Portsmouth. The Navy, Army and Air Force Institutes, or NAAFI, was first created by the government in 1921 to run recreational establishments needed by the Armed Forces, and to sell goods to servicemen and their families.

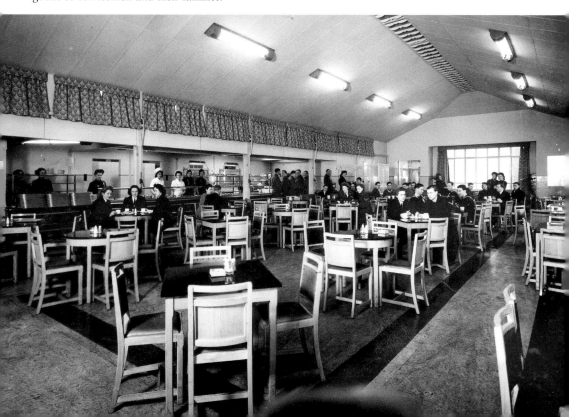

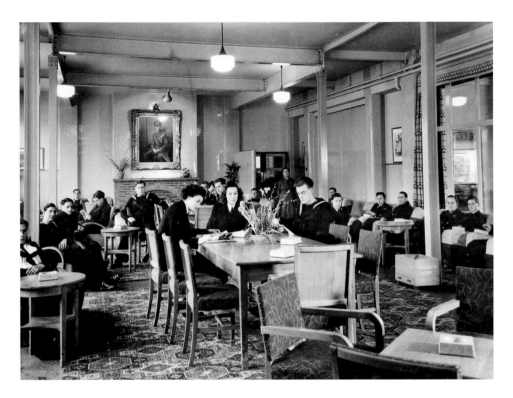

View of Services Men and Women in the Lounge of the NAAFI Services Club
Although the NAAFI had considerably expanded its operations during the war, it primary role had still been directed to the provision of canteens and the sale of essentials. However, the Portsmouth NAAFI was part of a new venture, being the first in a building programme to include restaurants, lounges, bars, reading and writing rooms, music and television rooms, games rooms and ballrooms, plus a military and naval centre. Seen here in a further 1946 photograph is the lounge of the NAAFI Services Club in Portsmouth.

HM Prison, Kingston

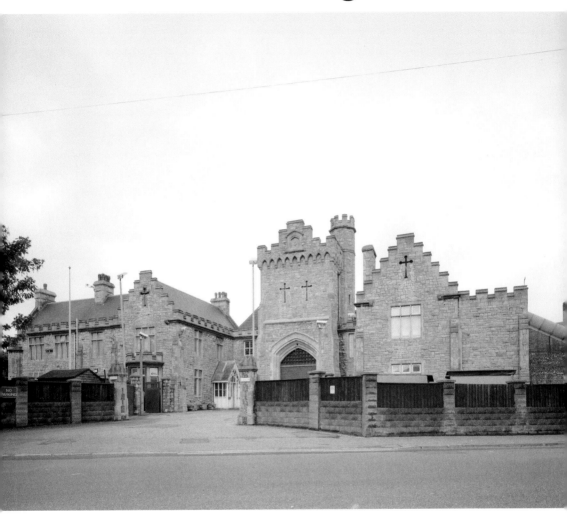

Exterior Gateway and Flanking Houses
The main entrance to the high-security prison in the Kingston area of Portsmouth photographed in May 1995. Officially named HM Prison Kingston, the institution was finally closed on 28 March 2013 as part of a wider closure of older prison buildings. Currently the site is being developed into 230 new homes (157 flats and seventy-three family properties).

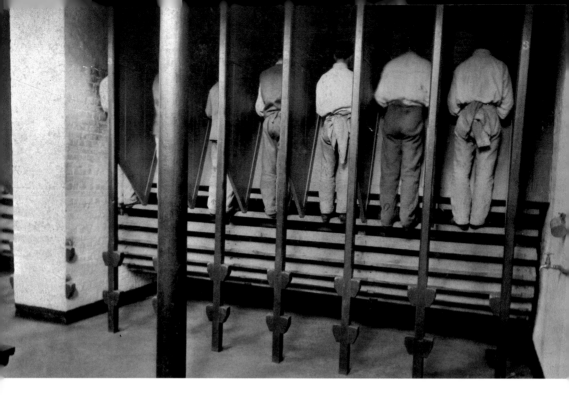

A Row of Men Working the Treadwheel
Kingston Prison dates to 1877, when prison life was considerably more brutal than in today's world. Here, in this late nineteenth-century view of the prison, inmates are working the treadwheel. Designed to keep convicts occupied, the wheel was kept rotating by each prisoner stepping on a series of slats, and as the wheel turned the prisoners were forced to maintain a steady stepping pace. It continued to be used in British prisons until abolished by the Prisons Act of 1898.

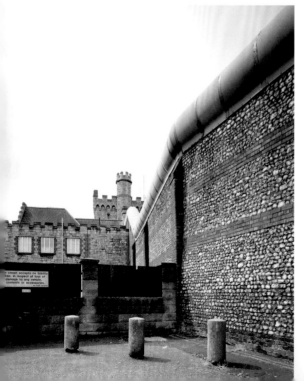

General View of the Perimeter Wall
The outer perimeter wall of the prison, seen in May 1995. Originally constructed on a radial design principle, the corridors of the prison branched out from a central hub and from where the inmates could be seen from a central observation point that provided visual access to all wings. It was based on an idea developed by the philosopher Jeremy Bentham, who believed that the radial design had a much wider application, allowing managers of workplaces and hospitals to more effectively control these units. If given his way, Jeremy's brother, Samuel, would have introduced a similar design into the construction of a new naval dockyard.

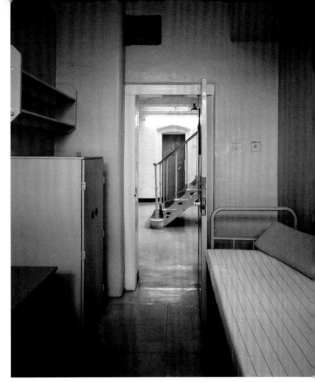

Right: Interior Cell
Interior cell of Kingston prison as photographed in May 1995. The current proposals for redevelopment of the prison site will see some of the cell blocks, these having Grade II-listed status, being restored and converted into apartments. The listed walls will be retained while the gatehouse will be adapted to house a small café.

Below: The Kitchen
Interior view of the prison kitchen as seen in May 1995.

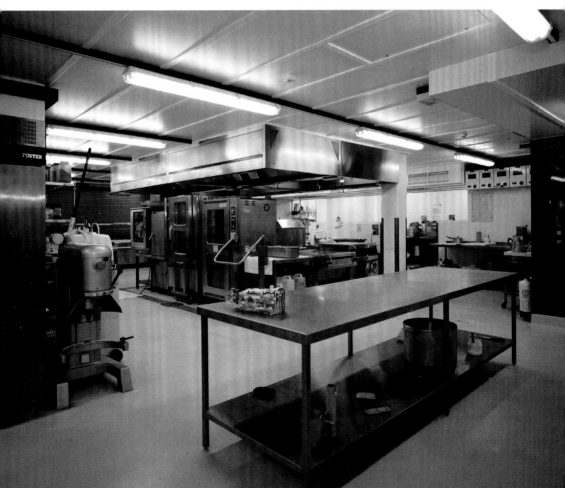

A Densely Packed City

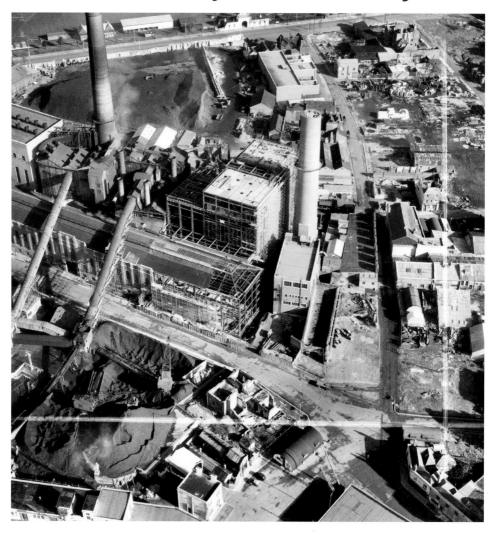

Portsmouth Power Station and Warblington Street, Portsmouth, 1951
When it ceased generating power in March 1977, the Portsmouth power station occupied an area bordered by Gunwharf Road, St George's Road and Warblington Street. This and the following aerial view both date to 1951, when the station was pumping between 400,000,000 and 500,000,000 units of electricity into the national grid. As can be readily appreciated, the generating station and accompanying buildings totally overshadowed the surrounding skyline, with final removal by 1983 allowing the area to be redeveloped as a site for homes.

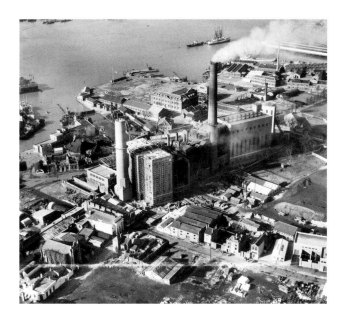

Portsmouth Power Station and Camber Dock, Portsmouth, 1951
It was from the camber that seawater was drawn for condensing purposes while colliers used the Camber Dock to deliver over 170,000 tons of coal every year. It was during the 1890s that the location close to the camber was first developed by Portsmouth Corporation for the generation of electricity, with later expansion, including the building of the two chimneys, occurring during the interwar years. While the power station no longer exists, its original foundation stones have been relaid in Armory Lane.

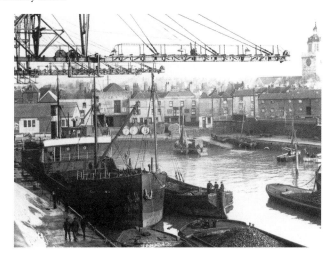

General View of the Camber, Portsmouth, Looking East
The Camber Dock, photographed sometime around 1910, with a number of coal-laden barges waiting to be unloaded to meet the demands of the nearby power station. Still an active port, but on a small scale, it is home to the local fishing industry and provides berths for small coastal commercial vessels and private pleasure craft.

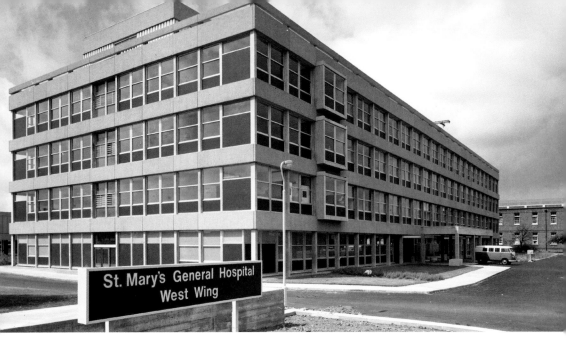

Above: View of the Completed West Wing of St Mary's General Hospital in Portsmouth
St Mary's Hospital west wing, seen here in 1967. Originally the site of Portsea Island Workhouse, built during the mid-1840s, its role in caring for the sick at that time was much restricted and confined only to the poorest members of society. Its real establishment as a hospital came in 1898 when it began specialising in medical care, at which time it was renamed the Portsea Island Union Infirmary.

Below: View of St Mary's General Hospital in Portsmouth
A further view of St Mary's Hospital, as seen in 1967. The term 'infirmary' had long ceased being used by that date, the hospital since 1930 being officially known as St Mary's Hospital. Many of the departments formerly at St Mary's, including acute services, have been transferred to the Queen Alexandra Hospital in Cosham, with St Mary's concentrating on day surgery, outpatient and diagnostic services, and minor injury and illness treatment.

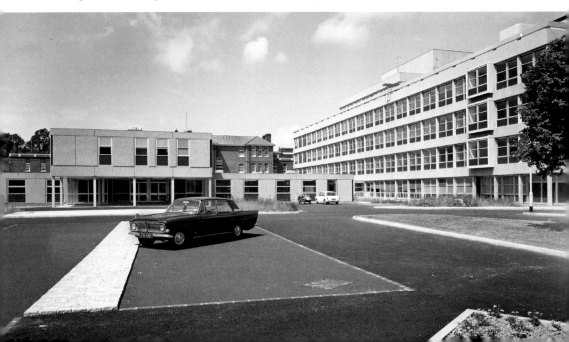

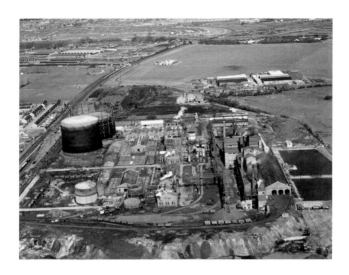

Hilsea Gasworks, 1949
Made redundant through the arrival of North Sea natural gas, the Hilsea gasworks is seen here in an aerial photograph dating to 1949. Some nine years earlier it had been a less impressive sight, having been the target of a direct hit by the Luftwaffe in August 1940.

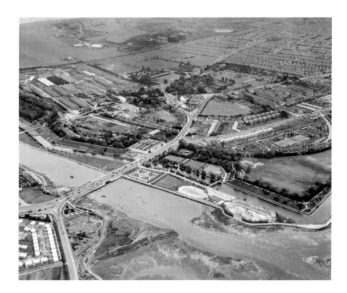

Ports Bridge, Ports Creek, Hilsea Lido and Environs, Hilsea, 1946
A general aerial view of Hilsea taken on 3 October 1946. Running across the centre of the photograph is Ports Creek, with the Lido clearly visible to the right. First opened in July 1935, it was once the place to be seen, with residents from all over Portsmouth drawn to a main pool, which could accommodate some 900 swimmers. Here, also, national diving championship competitions, water spectaculars and displays by the League of Health and Beauty were once held. To view these events, the Lido had seating for a thousand spectators.

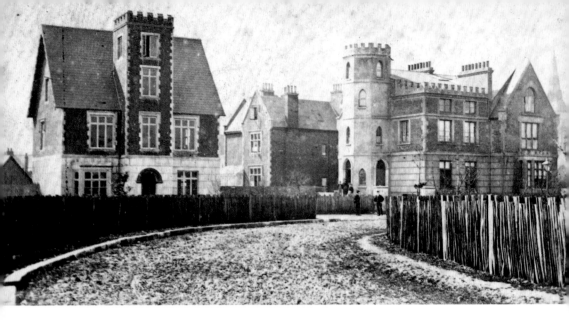

Above: A View from Albany Road Looking Towards Houses on Nelson Road
Having looked at some of the places where residents of Portsmouth were employed, entertained and shopped, next is a glimpse at the houses of the town. Portsea Island, usually referred to as Portsmouth, is the most densely packed city in the United Kingdom – this placing a great premium on land for housing. The result is the majority of houses in Portsmouth cover a relatively small area of ground – even the more fashionable houses built for the middle class. Take, for instance, this late nineteenth-century view of houses visible from Albany Road looking towards Nelson Road. Over time this area has become even more compact, with smaller houses having replaced some of their larger Victorian predecessors, although the house with the round turret survives.

Below: The Exterior of Paulsgrove House, Seen from the South-east
Not surprisingly, the very largest houses, even during the seventeenth century, if they were built at all, were on land well away from the military-industrial complex centred on the dockyard. Paulsgrove, once a small hamlet situated on the old Portsmouth to Southampton road, was one such location for those who required extensive lands for a large house, with Paulsgrove House being an example. Seen here in June 1921, mostly Victorian but with some parts earlier, the house was demolished in December 1970 to make way for the M27 Motorway.

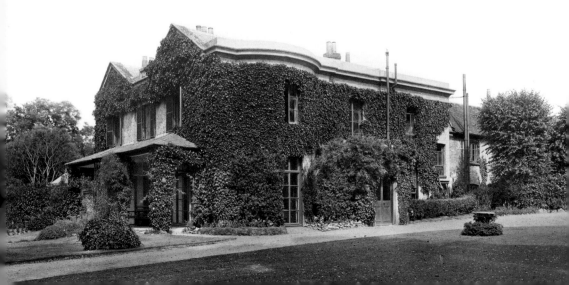

Above: The Rear of East Cosham House, Portsmouth
East Cosham House in 1923. Cosham, once a village in its own right but now a suburb of Portsmouth, was once far enough from the area of Portsmouth dominated by its military-industrial complex to provide space for large residences. Along the Havant Road a number of large villas were built, including East Cosham House, which possibly dates to the late eighteenth century.

Below: A Series of Terraced Lawns and Borders in the Gardens at East Cosham House, Portsmouth, June 1923
The house still stands, receiving several later alterations, and currently serves as a residential home for the elderly.

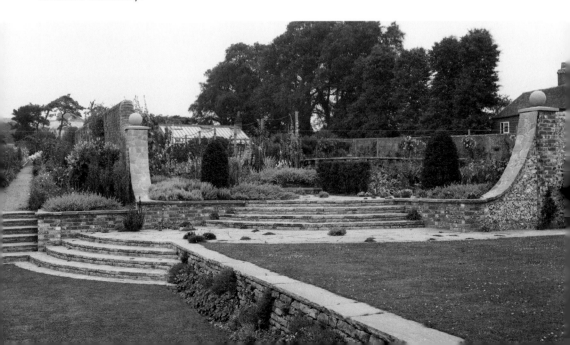

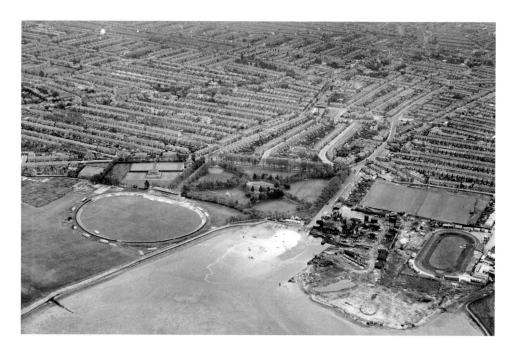

Alexandra Park and Environs, Hilsea, 1946
The density of housing in Portsmouth can be readily appreciated from this aerial view of Hilsea, taken in 1946. In the foreground is Alexandra Park, purchased by Portsmouth Corporation in 1888 and developed as a recreation ground. The park now also incorporates the Mountbatten Centre sports facility. All other available space, even as early as 1946, was already crammed with compact terraced housing.

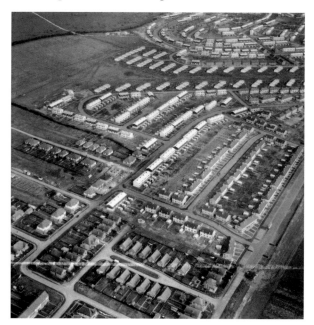

Housing Surrounding Bude Close and Mousehole Road, Paulsgrove, 1948
Portsmouth hit a massive housing crisis in the 1940s, this a result of the intensive bombing that had destroyed large tranches of the city during the war. To help remedy the situation, pushing the suburbs of Portsmouth further north, the Corporation purchased large areas of land in Paulsgrove in a major construction programme towards the end of 1945. This aerial view of Paulsgrove, dating to December 1948, shows the considerable progress by that date of the construction of housing.

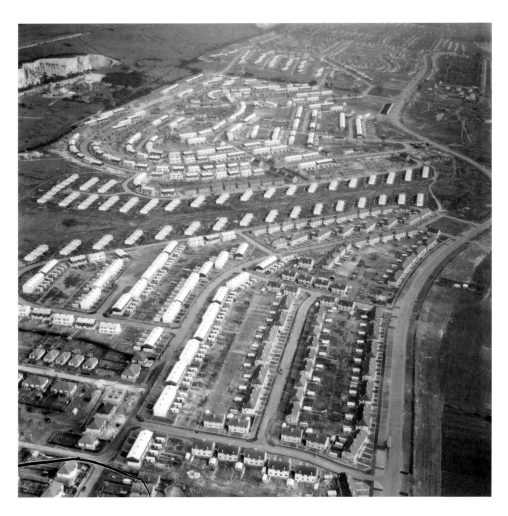

Paulsgrove Housing Estate, Paulsgrove, 1948
A further view of Paulsgrove, taken on 8 December 1948. The large swathe of open land running through the centre of the photograph was being deliberately undeveloped at this time to meet government proposals for a series of new long-distance roads that had been planned in 1943 and would eventually manifest in the construction of the M27 Motorway.

Places of Worship

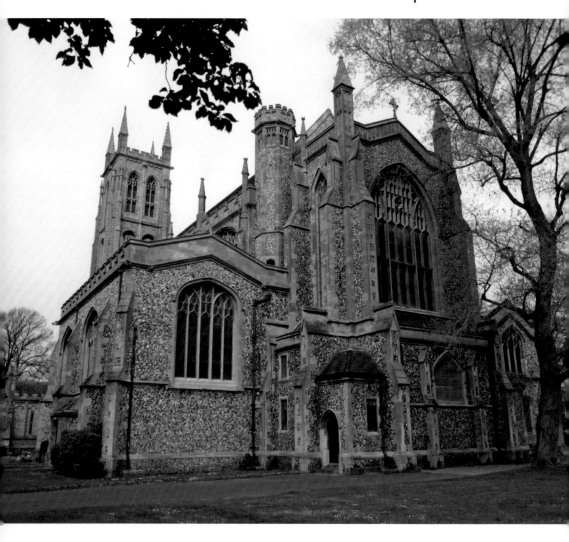

St Mary's Church, Fratton Road
To meet the spiritual needs of the constantly expanding Portsmouth community, it became necessary to rebuild and enlarge what was at one time the only parish church outside of Old Portsmouth, the medieval church of St Mary's. This survived into the nineteenth century, was rebuilt in 1843, and then completely replaced during the late 1880s. However, simply bringing a much larger church to the site fell short of actual need, with numerous other churches built on Portsea Island, or close-by, from the mid-eighteenth century onwards.

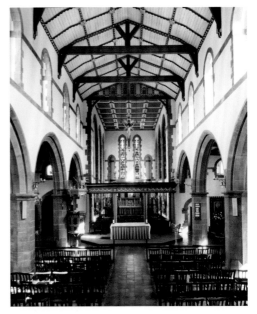

Interior View of St Alban's Church
Copnor, a small village until the late
nineteenth century, saw rapid expansion
at the beginning of the twentieth, with
St Alban's Church on Copnor Road opening
in 1914, followed by St Cuthbert's a year
later. Both had red-brick exteriors, the
former with its nave of whitewashed walls
and colour and sandstone arcades, seen here
in 2010.

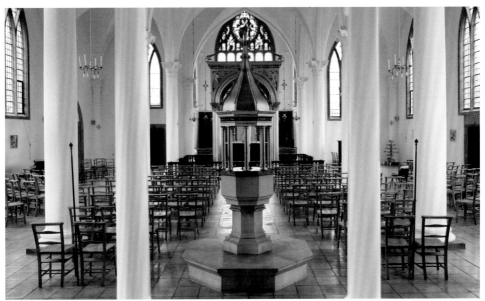

Interior View of St Philip's Church
The Highbury Estate, immediately north of Ports Creek and south of the Portsmouth–
Southampton railway line, was built as a residential area in the 1930s, but lacked any real
facilities to bind the community together other than the Church of St Philip, built between 1936
and 1938. This photograph, taken in February 2010, shows the four-bay nave of St Philip's,
while in the foreground can be seen a plain octagonal font with its gilded and painted cover.
Designed by Sir Ninian Comper, one of the last of the great Gothic revivalists, the emphasis at
St Philip's is on simplicity, this even extending to the church having a single bell rather than a
more enlightening peal.

St Agatha's Church
The former church of St Agatha's, Landport. Built between 1893 and 1895, this church was built to meet the neglected needs of those living in the slums of Portsea and Portsmouth town. Here, Father Robert Dolling (1851–1902), from 1885 onwards, set about bringing Christianity to this unattractive and poverty-stricken area with its particularly high population of Irish-born settlers. St Agatha's Church was his crowning achievement. Note the unfinished south-west tower.

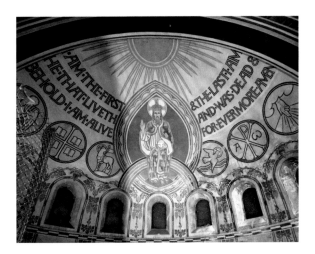

Wall Painting in the Apse of St Agatha's Church
A magnificent *c.* 1901 sgraffito plaster mural in the apse of St Agatha's Church, Landport, photographed in October 1983. In carrying out his important work in Landport, Robert Dolling initially opened several schools, converted a disused Baptist chapel into a gymnasium and organised various activities for the poor. It was to meet the more direct spiritual needs of that same community, many of whom he was now drawing into the church, that he set about building St Agatha's.

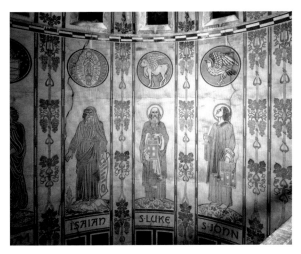

A further view of the apse of St Agatha's Church, as seen in October 1983. The plaster mural is the work of Heywood Sumner, a friend and disciple of William Morris. In style St Agatha's is Italianate Romanesque, having a very broad nave and walls of bare stock brick and rounded arches highlighted in red brick. St Agatha's ceased meeting the spiritual needs of the local community in 1954, the resident population of Landport having declined following wartime damage to the housing stock and relocation to other parts of Portsmouth. Instead, after a period in use as a store and some limited community use, the building has seen a return to religious worship, now as a church for Anglicans who wish to draw nearer to the ideals of Roman Catholicism.

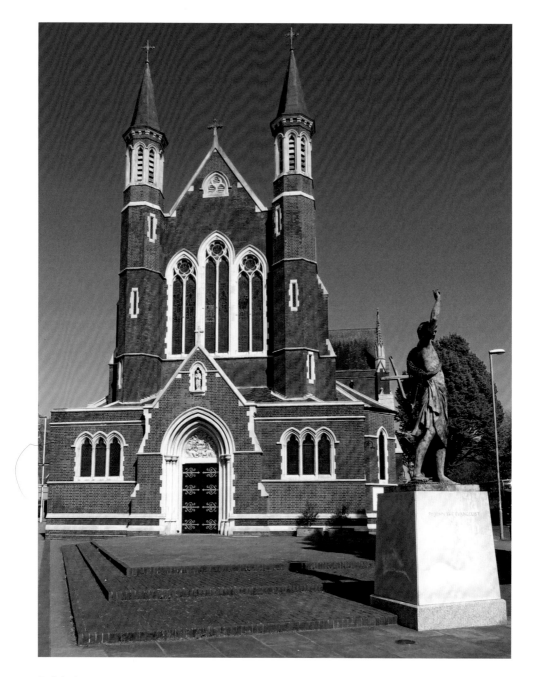

St John's

The west front of the Roman Catholic Cathedral of St John's with the statue of St John the Evangelist in the foreground. With plans in the 1870s already in place to create the new Catholic diocese of Portsmouth, the projected new church was to be of a size that would soon see it becoming a cathedral. With building work beginning in 1877, the west front was not completed until 1906.

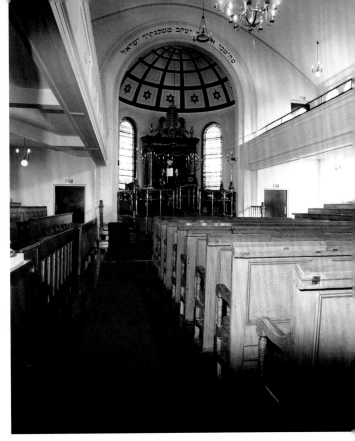

Portsmouth and Southsea Synagogue

Although Christianity has long predominated in Portsmouth – few cities having both a Catholic and an Anglican cathedral – it is far from the only faith. A Jewish community dates back to at least the 1740s, a largely mercantile community drawn to Portsmouth to meet the needs of naval seamen. A synagogue was initially built in Curzon Howe Row (formerly White's Row), with a new synagogue opened in The Thicket, Southsea, in September 1936.

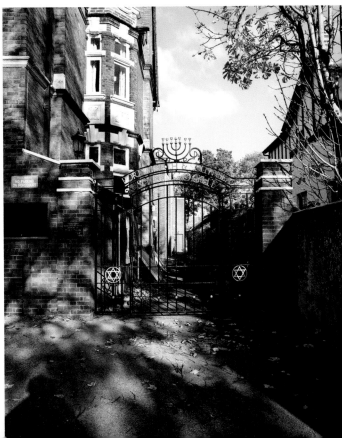

View of the Synagogue Gates

While the earlier photograph (above) is an interior view of the synagogue in The Thicket, looking towards the ark and dating to November 2001, this view is of the exterior of the building. In establishing the new synagogue, many of the treasures from the earlier building were carefully placed in the new building, including the stained-glass windows bearing the Ten Commandments, the original Ark, chandeliers and the 'everlasting light' – all visible in the previous photograph.

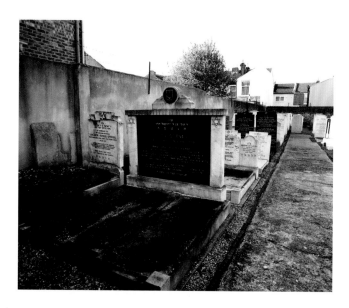

The Tomb of Harry Sotnick, First Jewish Lord Mayor
The Jewish burial ground in Fawcett Road. Established in 1749, the oldest recognisable tombstone dates to 1769. In the cemetery are buried a number of Jews who have played a significant role in the civic life of Portsmouth, including Alderman Emanuel Emanuel JP (1808–88), whose monument alongside Canoe Lake has already been mentioned. The particular tomb seen in this photograph is that of Harry Sotnick, Lord Mayor of Portsmouth in 1963.

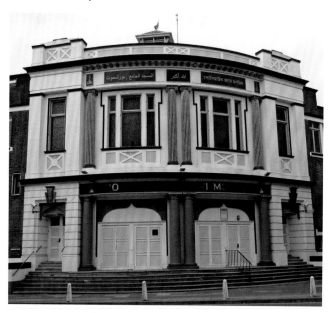

Portsmouth Mosque
A more recently established place of prayer in Portsmouth is the Jami Mosque on Bradford Junction, a former cinema building (the Plaza, later Gaumont, which first opened in September 1929) and is one of three mosques in Portsmouth.

Portsmouth Aerodrome

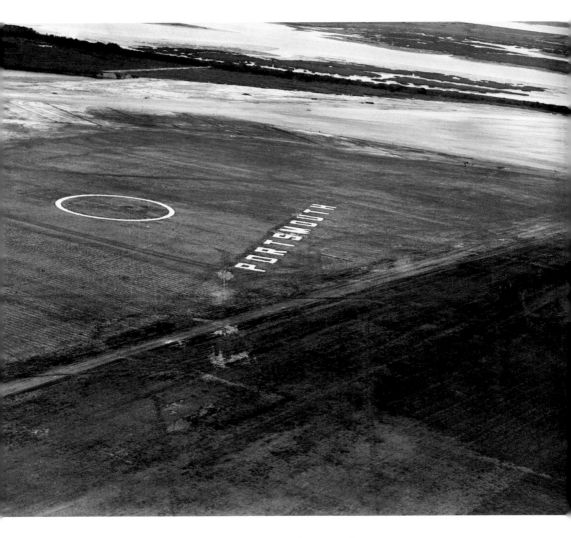

The Landing Circle at Portsmouth Aerodrome, Anchorage Park, 1932

This, and the following two photographs, show Portsmouth Aerodrome in June 1932, shortly before its official opening on 2 July of that same year. Seen here is the landing circle, a ground to air signal that indicated the site of the aerodrome and where to land. On the occasion of its opening, those assembled for the event were treated to an aerobatic display by the RAF and an over-flight by Graf Zeppelin, a giant German passenger airship. Work on constructing the aerodrome began in November 1930 with clearing and levelling the 275-acre site, which also involved removal of an old military fort.

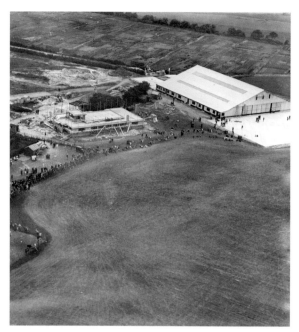

Portsmouth Aerodrome, Anchorage Park, 1932
With the landing circle beginning to be surrounded by spectators, it is possible that it is 30 June, the day that Handleys of Southsea, who now also sold private aircraft through their Palmerston Road store (enquiries were to be made at the heating, plumbing and aircraft section!) were demonstrating the capabilities of the Robinson Redwing two-seat single-engined biplane that they hoped to sell to future weekend pilots. This photograph also provides a view of the facilities that were still, in part, under construction: hangars, offices, club facilities and a restaurant.

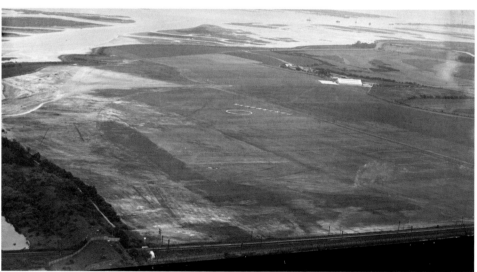

Portsmouth Aerodrome, Anchorage Park, 1932
A more distant view of the airfield in June 1932. Owned by Portsmouth Corporation, the construction of the aerodrome was regarded as a valuable step in advancing the fortunes of the city, but with the airfield positioned between the Portsmouth–London railway line and Langstone Harbour, any later expansion of the aerodrome would prove impossible and this proved its eventual downfall. Nevertheless, it did see the introduction of regular ferry flights to the Isle of Wight and aircraft construction undertaken by Airspeed Ltd. Closed at the end of 1973, the former site of the airfield has been redeveloped for housing, retail and industrial units.

Bombed but Unbeaten

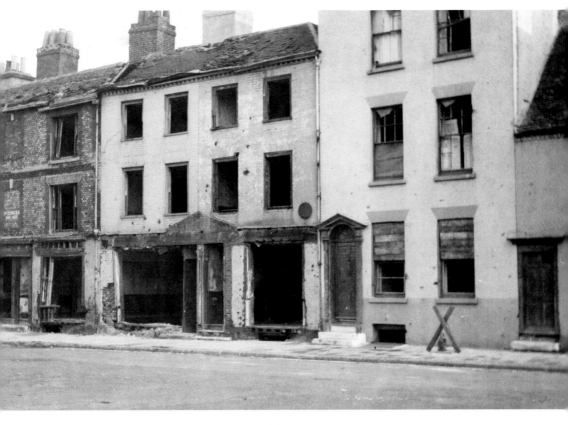

Exterior View of a Row of Bomb-damaged Buildings in St George's Square
Mention has been made of the air raid on the night of 10/11 January 1941 that saw destruction of Clarence Pier and inflicted heavy damage on Handleys Store in Palmerston Road. This was one of the most serious raids of the war and saw 300 German aircraft dropping 25,000 incendiaries and numerous high-explosive bombs over a period of seven hours. A second of the more serious raids took place exactly two months later, on 10 March 1941, when thousands of incendiaries were dropped together with 250 high-explosive bombs. It was that latter raid that caused a number of fires in St George's Square, and destruction of several properties as seen in this photograph.

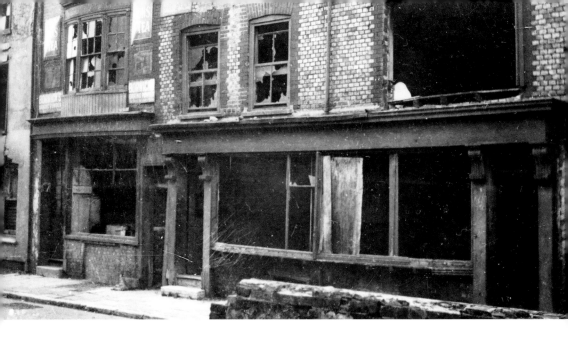

Above: A View, from the South, of the Extensive Bomb Damage Sustained by the Buildings at Nos 1–4 Clock Street

A view, from the south, of the extensive bomb damage sustained by the buildings at Nos 1–4 Clock Street on 22 December 1940. The two massive raids of 10 January and 10 March 1941, together with an earlier major raid on 24 August 1940, were among an official total of sixty-seven air raids mounted on the city. In all, 1,320 high-explosive bombs and 38,000 incendiary bombs were recorded as falling on the city, with 930 civilians killed and a further 2,837 injured.

Below: Bomb-damaged Buildings in North Street

Over 6,000 residential properties in Portsmouth were entirely destroyed during the war with more than 6,000 seriously damaged. It was this that caused the post-war housing crisis in the city, leading to the creation of several new housing estates on the fringes of Portsea Island.

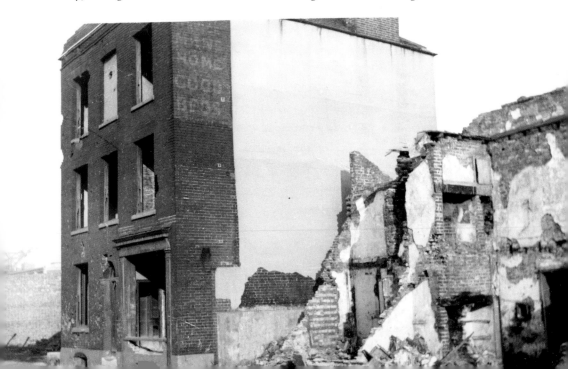

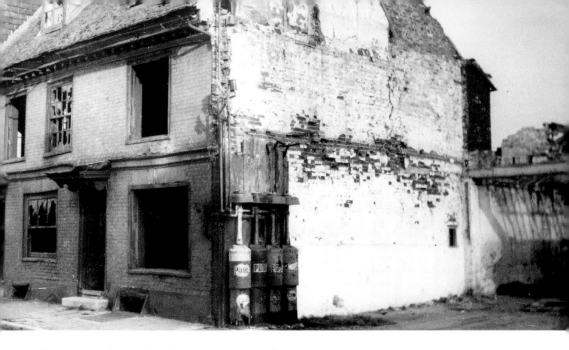

Above: Bomb-damaged Buildings at Nos 35 and 36 Havant Street
Exterior view of the bomb-damaged building at Nos 35 and 36 Havant Street, showing four gas canisters attached to the gable end wall.

Below: The Bomb-damaged St George's Church
Exterior view, from the south, of the bomb-damaged St George's Church undergoing roof repairs following the raid of 10 March 1941. This raid, which primarily affected the southern part of the city, also brought destruction to the Royal Sailors' Home Club and the former Jewish synagogue in Curzon Howe Row. Although St George's Church still stands, having been restored, it lacks much of its former Georgian grandeur, having lost many of its early fittings.

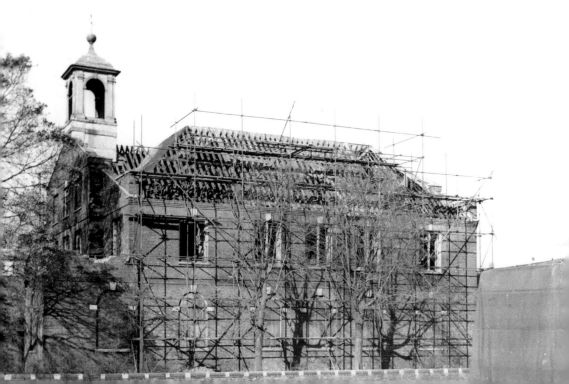

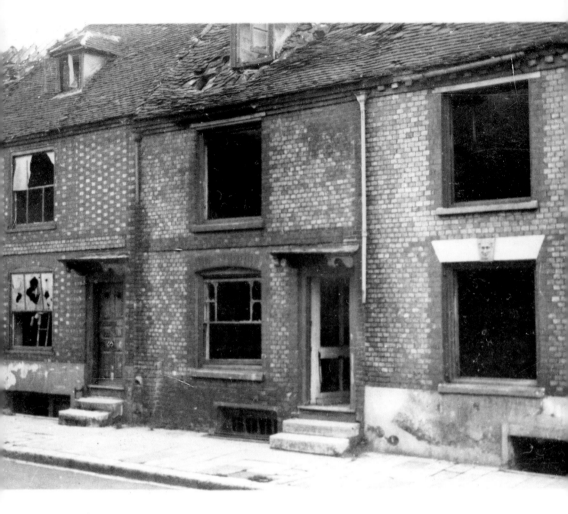

Bomb Damage on King Street
Exterior view of a severely bomb-damaged row of buildings on King Street.

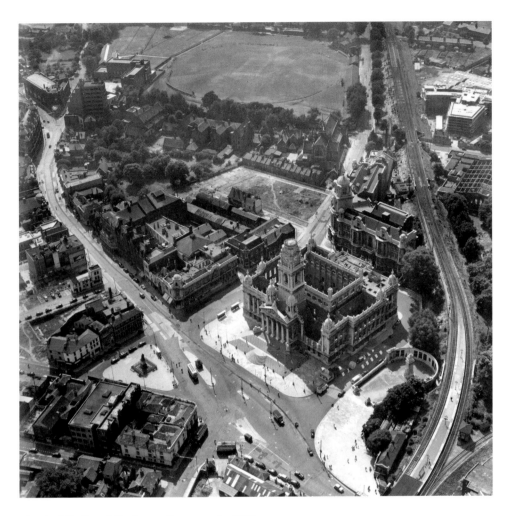

The Guildhall and Environs, Portsmouth, 1951
The Guildhall was another of the buildings destroyed in the major night raid of 10/11 January 1941. This aerial view dates to July 1951 when work on its reconstruction had begun. It was from the Guildhall that all civil defence operations were co-ordinated, the destruction of the Guildhall causing major problems for the police, ambulance, fire services, as well as for air-raid wardens and various voluntary bodies. The solution, given that air raids on Portsmouth had long been predictable in the event of war, would have been underground control rooms as had been built in other authority areas.

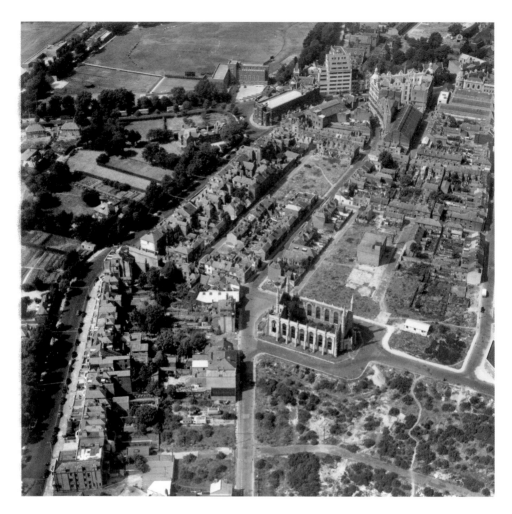

The Ruin of St Paul's Church, St Paul's Road and Environs, Portsmouth, 1951
An aerial view dating to July 1951 showing damage to St Paul's Church in St Paul's Square. The church was a further victim of the raid on the night of 10/11 January 1941, with little of the church surviving intact. In post-war years local parishioners attempted to have the church rebuilt, but it was eventually demolished and the surrounding area redeveloped.

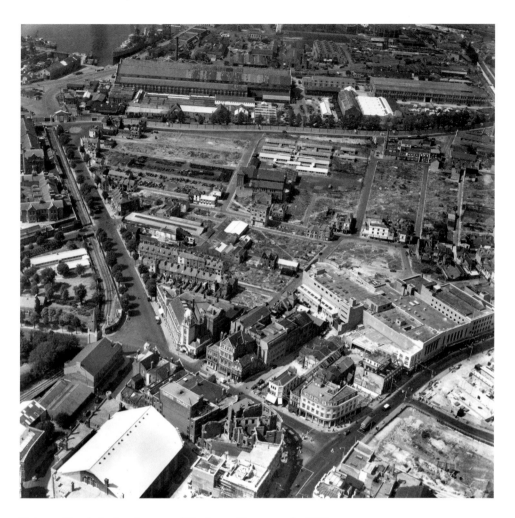

Unicorn Road, Spring Street and Environs, Portsmouth, 1951
The area of Portsea around Unicorn Road, July 1951. Unicorn Gate and a small section of the dockyard can be seen (upper left). Although work in Portsmouth was underway on redeveloping the city, large areas have seen no more than clearance, with the city still far from having finalised plans for how it was to be rebuilt.

About the Archive

Many of the images in this volume come from the Historic England Archive, which holds over 12 million photographs, drawings, plans and documents covering England's archaeology, architecture, social and local history.

The photographic collections include prints from the earliest days of photography to today's high-resolution digital images. Subjects range from Neolithic flint mines and medieval churches to art deco cinemas and 1980s shopping centres. The collection is a vivid record both of buildings that are still part of everyday life – places of work, leisure and worship – and those lost long ago, surviving only in fragile prints or glass-plate negatives.

Six million aerial photographs offer a unique and fascinating view of the transformation of England's towns, cities, coast and countryside from 1919 onwards. Highlights include the pioneering photography of Aerofilms, and the comprehensive survey of England captured by the RAF after the Second World War.

Plans, drawings and reports provide further context and reconstruction artworks bring archaeological sites and historic buildings to life.

The collections are housed in a purpose-built environmentally controlled store in Swindon, which provides the best conditions to preserve archive items for future generations to enjoy. You can search our catalogue online, see and buy copies of our images, as well as visiting our public search room by appointment.

Find out more about us at HistoricEngland.org.uk/Photos
email: archive@historicengland.org.uk
tel.: 01793 414600

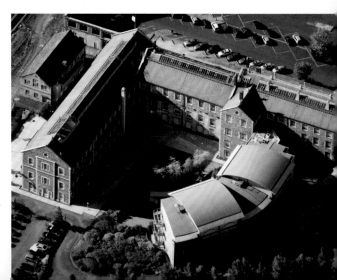

The Historic England
offices and archive store in
Swindon from the air, 2007.